NAILSWORTH & WOODCHESTER

THROUGH TIME

Howard Beard

AMBERLEY PUBLISHING

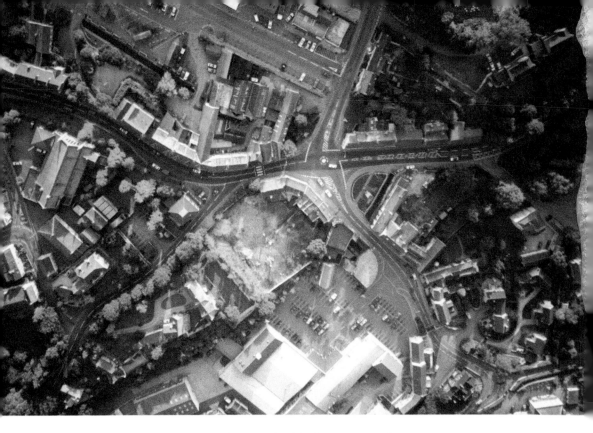

Nailsworth from a hot air balloon, photographed in the summer of 1993

This book is dedicated to Ann Makemson, who established the Nailsworth Archive and for fifteen years ran it for Nailsworth Town Council. With the help and encouragement of local people, especially her parents, she has done much to preserve the history of Nailsworth and its surrounding area.

First published 2010

Amberley Publishing Plc
Cirencester Road, Chalford,
Stroud, Gloucestershire, GL6 8PE

www.amberley-books.com

Copyright © Howard Beard, 2010

The right of Howard Beard to be identified as the
Author of this work has been asserted in accordance
with the Copyrights, Designs and Patents Act 1988.

ISBN 978 1 84868 050 0

British Library Cataloguing in Publication Data.
A catalogue record for this book is available from
the British Library.

Typeset in 9.5pt on 12pt Celeste.
Typesetting by Amberley Publishing.
Printed in the UK.

Introduction

Nailsworth and Woodchester lie next to each other on the A46 just south of Stroud, but historically they could hardly be more different. Nailsworth, measuring around 1,600 acres in extent, was created in the 1890s from parts of the ancient parishes of Avening, Horsley and Minchinhampton. Its development mirrors that of Stroud in that it grew up naturally over the centuries at the convergence of several valleys.

The cloth industry played an important part in the history of Nailsworth, which contains the sites of some fourteen mills. As late as the eighteenth century the settlement essentially comprised two hamlets: Lower Nailsworth, roughly the area where George Street, Spring Hill, Fountain Street and Bridge Street meet, and Upper Nailsworth, which consisted of the part of the present town centred around Cossack Square.

It was firstly the creation in 1780 of the new Bath to Gloucester road along the valley bottom, then the opening in 1867 of the Midland Railway branch line to the town from Stonehouse, which together stimulated Nailsworth's rapid expansion. The development of Fountain Street linking the two former hamlets, and of Market Street, shows how the ready availability and easy transport of brick and slate in the second half of the nineteenth century encouraged this spurt in urban growth.

Nailsworth has been well served with places of worship. A medieval chapel of ease to the mother church at Avening is reported to have existed at Bannut Tree House. In 1794 the distinctive 'Pepperpot' Church was erected and stood for just over a hundred years. Between 1898 and 1900 it was replaced by the present St George's. During the second half of the nineteenth century, Shortwood and Inchbrook also acquired Anglican places of worship. Quakers flourished in Nailsworth from the 1660s, building a meeting house in Chestnut Hill about 1680. Around the same period, the Presbyterians – later Congregationalists – became established at Forest Green. The Baptists followed, building their chapel at Shortwood in 1715. By the early years of the nineteenth century Shortwood is said to have been the largest country Baptist meeting in England. A doctrinal dispute led to the erection, in 1868, of a second Baptist chapel in Bristol Road, later taken over by the Methodists.

Woodchester, by contrast with Nailsworth, is an ancient parish; its name is spelt variously as Udecastre, Wuducastre, Wodecestre,

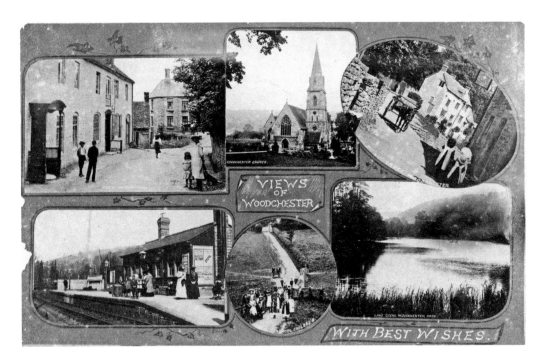

A 'multi-view' picture postcard of scenes in Woodchester, published around 1910

Widuceastre, Wydchestre and Wychestre. Although consisting of two distinct hamlets, North and South Woodchester, the village today is keen to stress its oneness as a community.

The parish is celebrated internationally for its extensive Roman villa, the highlight of which is the splendid Orpheus Mosaic. A replica of this was sold in June 2010 and may, possibly, leave the district.

Perhaps equally renowned is the Mansion, erected in a gloriously unspoilt valley setting in the 1860s, in Cotswold Tudor style, and left fascinatingly incomplete. It now forms a major attraction within the district. The Mansion was the creation of William Leigh, a convert to Catholicism, whose influence led to the founding of a church at Inchbrook in 1849, together with a Dominican monastery, occupied in 1853, and a Franciscan convent, opened a few years later.

In 1863 the ancient Anglican church of St Mary, built on the Roman Pavement site in North Woodchester, was demolished and replaced in a new location by the present building. The parish, like Nailsworth, has several ancient mills and, currently, two schools – Woodchester Endowed C of E School, near St Mary's in North Woodchester, and St Dominic's R C School at Inchbrook.

Using old and modern photographs it is intended to record in the following pages how these two very different parishes – Nailsworth and Woodchester – have changed and evolved through time.

NAILSWORTH

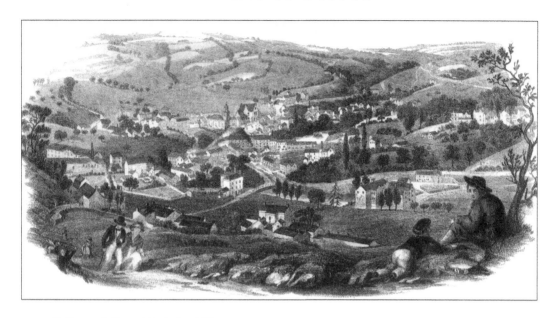

Nailsworth from Watledge Hill

The early nineteenth-century print is entitled 'From Watledge Hill'. Today we would say 'from the W'. It shows Egypt Mill and the large house which later became The Railway Hotel; the line itself was only put in during the late 1860s. The original version – shown here – was reissued to include The Subscription Rooms after their erection in 1852. The Pepperpot Church – the tower explains its name – is clearly visible in both the print and the photograph, which must date from the 1880s or early 1890s. In both images, note the impressive size of Nailsworth Mill before its truncation to allow for the widening of Fountain Street.

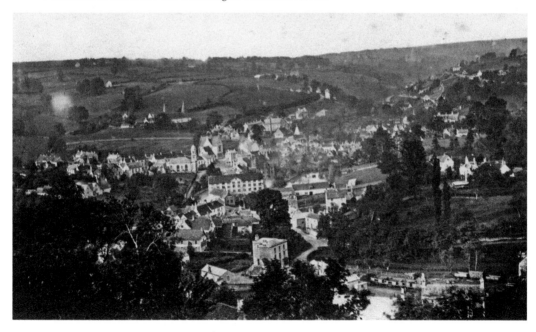

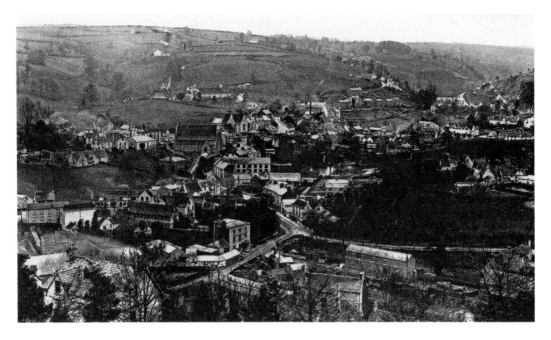

Later views from the 'W'

By the early years of the last century, when the upper picture was taken, the 'Pepperpot Church' had been replaced by the present St George's, Nailsworth Mill had been altered and Fountain Street further developed. On the approach to what is now Egypt Mill's car park, C. W. Jones' coal firm offices have also appeared, located between piles of fuel. The long building to the right was his storage warehouse. The modern picture shows how tree growth, although providing an attractive autumn foreground, obscures much that was visible a century ago.

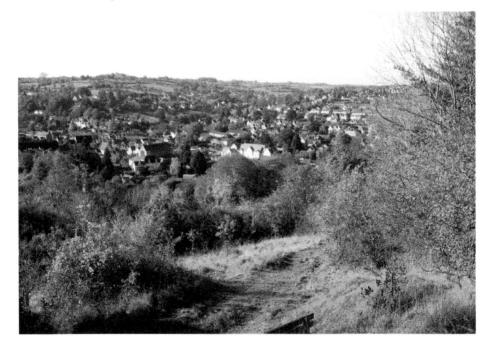

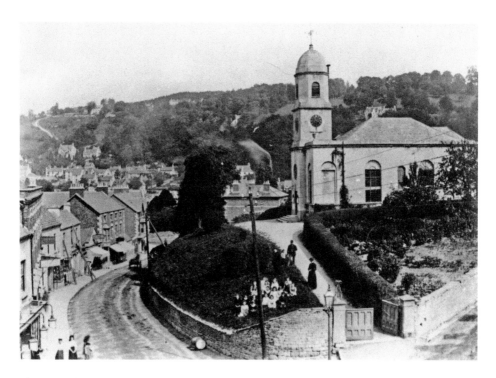

The Church

It's possible that as little as a decade separates these two images, the later coloured postcard dating from around 1905. The gas lamp is common to both. For half a century the clock removed from the 'Pepperpot Church' was housed in the wooden tower erected on the bank. In the 1950s it was resited in a purpose built structure near the George Hotel. It may possibly come as a surprise to some today that telegraph poles existed more than a century ago, and were so prominent. Note that when the church was rebuilt its approach drive was moved further up Church Street.

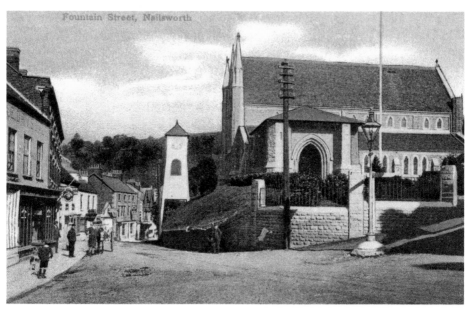

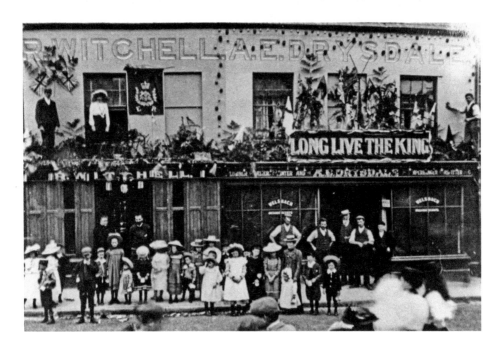

Shops at The Cross

In the summer of 1902 Nailsworth celebrated the coronation of King Edward VII and Queen Alexandra – an event which had in fact been postponed because of the King's serious illness. Here at The Cross, dressed in their best clothes, children pose for an un-named photographer – possibly Paul Smith, who took other pictures of the event in the town. Above shop window level the buildings remain substantially unaltered. In 1902 Robert Witchell ran a butcher's business in the premises shown on the left. Albert Drysdale's firm involved various occupations: they were plumbers, gas fitters, bell hangers, glaziers, painters and paper hangers.

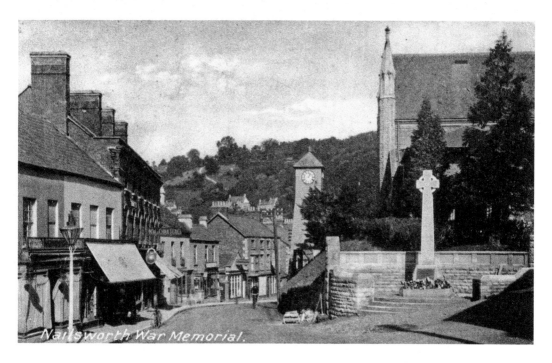

Nailsworth War Memorial.

Upper Fountain Street

By the time the sepia 1920s postcard view was taken, the churchyard wall had been breached to allow the insertion of Nailsworth's War Memorial (the gas lamp had been resited across the road). Shop window sun blinds are now also more in evidence. Further down the street the line of buildings is continuous. In the 1970s demolition took place and, in the gap, The Mortimer Gardens were created – gifted to Nailsworth in 1970 under the terms of the will of benefactor William Mortimer. The modern picture, taken in September 2005, shows the Farmers' Market, which now takes place regularly in the Gardens.

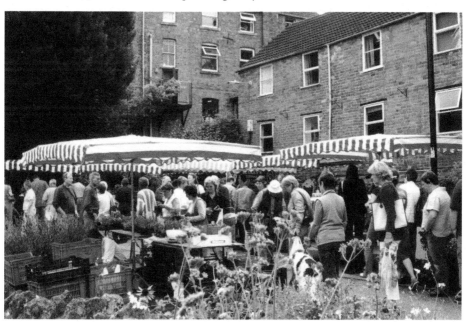

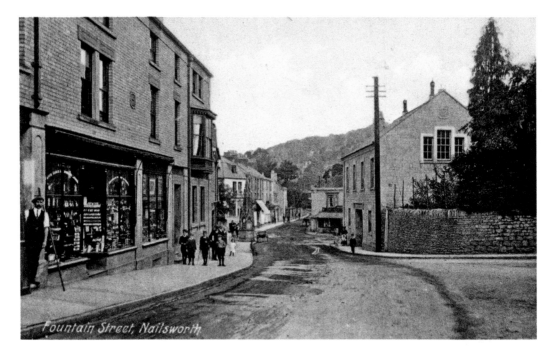

Fountain Street, Nailsworth.

Lower Fountain Street, looking down

The removal of the wall and trees on the corner of Tabram's Pitch has rather changed the right side of this scene. However, above shop window level, the buildings on the left remain little altered. In the Edwardian postcard view the business with the man standing next to it belonged to Alphonso Davis, listed in Kelly's 1910 Directory as a watchmaker and cabinet-maker. Note the children on the pavement: their presence is not accidental – the photographer knew that their parents would be sure to purchase copies of the postcard.

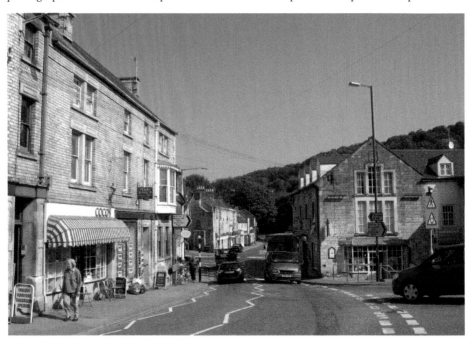

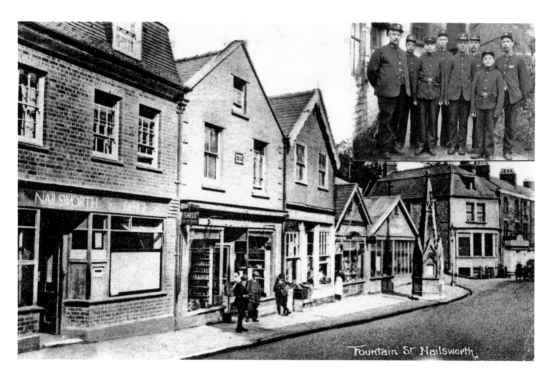

Fountain St Nailsworth,

The Post Office

Seen on the left, the Post Office has moved in recent years from Fountain Street to round the corner in the Tesco store in Old Market. The inset shows the staff around the time of the First World War. A Mr Ernie Belcher is on the left. The Fountain is in its original position; it has, of course, recently been re-sited nearby, although further back from the kerb. The small shops close to it were badly damaged in the 1931 flood, of which more later.

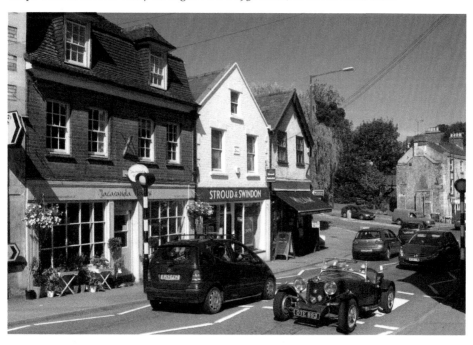

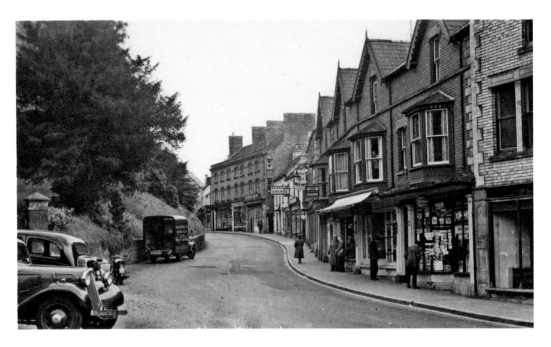

Lower Fountain Street, looking up

The earlier photograph dates from the 1950s. Allan's newsagents and booksellers are on the right and, further up, the sign for Taylor's Garage projects above the street. How different towns look with no white or double yellow lines and, in the days of far fewer vehicles, more relaxed parking.

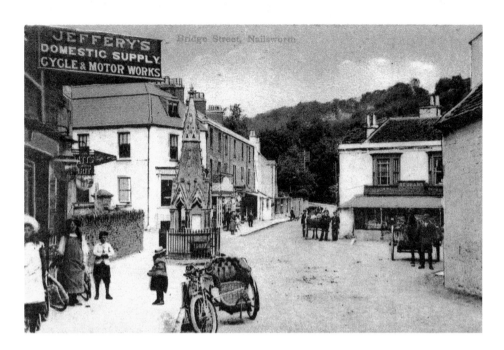

The Mini Roundabout

For many years Oliver Jeffery's cycle and motor works was a familiar landmark at the bottom of Fountain Street. It is now the office of the Stroud & Swindon Building Society. When this coloured postcard was sent in 1903 the pair of single-storey wooden shops mentioned earlier had not been put up. Dauncey's tailor's premises, immediately behind the fountain, were later demolished, giving better vehicular access into Spring Hill. Mrs Mary Hephzibah Redman's stationer's shop – from which the printed postcard was bought – has been replaced by a green open space and the town clock.

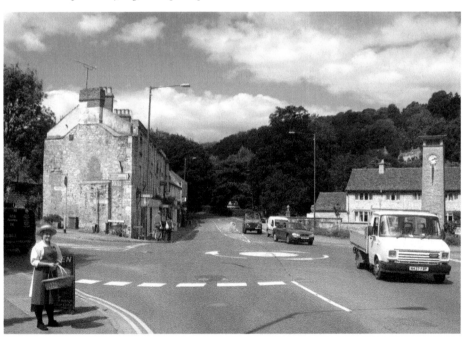

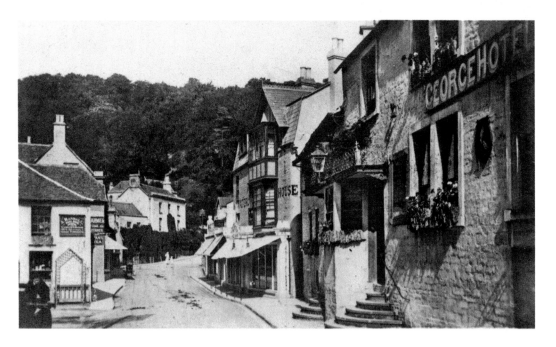

George Street, looking up

During the early years of the last century the author's great-grandfather, Stephen Beard, was gardener at the George Hotel, beyond which is John Morris' draper's shop. On the left can be seen Randall's carpenter's business and, further on, Harmer's, who dealt in confectionery, bakery and pastries. In 1989 the George Hotel was threatened with demolition. The modern picture shows the successful rooftop protest which resulted in its rescue.

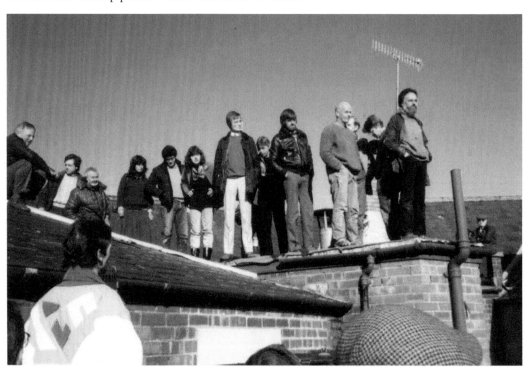

George Street, looking down

In the 1890s Whiting's shop was the scene of an explosion caused by the ignition of gunpowder stored there. Attached to the gabled building, out of shot to the right in the early picture, is the celebrated giant Victorian copper kettle. The inscription beneath it reads, 'MY JUBILEE 1887'. The image inset into the present-day photograph dates from 1990 and shows the kettle being taken down to be polished.

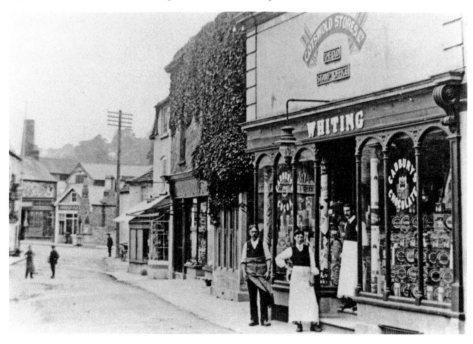

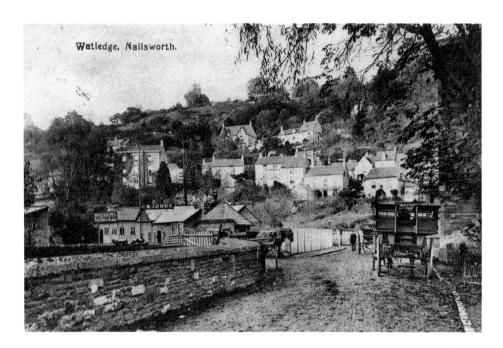

Watledge, Nailsworth.

Station Road

On the right of the Edwardian picture is the Railway Hotel. The photograph shows the trade signs for no less than three coal businesses, whose supplies arrived on the Midland Railway branch line via Dudbridge from Stonehouse. The most successful of these was the firm of C. W. Jones, whose 1910 directory entry reads 'coal and builders' merchant, assessor and collector of assessed and income taxes, poor rate collector and surveyor and rate collector to the Urban District Council' – clearly a busy man! His name can still be read on his former office building near Egypt Mill.

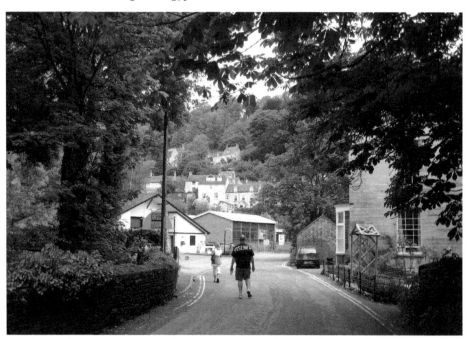

Watledge

A comparison of these distant views shows how much more heavily tree-covered the hillside is today. Housing development has also occurred during the century that separates the two images, notably at Watledge Bank on the right. E. P. Conway, Nailsworth's resident photographer for most of the first quarter of the last century, persuaded a group of children to pose for him.

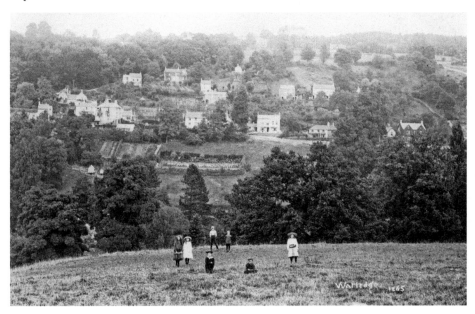

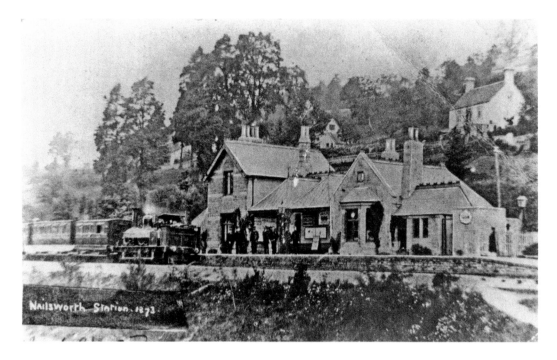

The Station

These pictures were taken about thirty-five years apart. As its caption indicates, the older one was taken in 1873, quite soon after the line opened in 1867. The design of the rolling stock confirms the early date of the image. Today tree growth prevents a similar view being taken. Instead, an Edwardian postcard is included, showing the station staff outside the finely designed main entrance. The building today is privately owned.

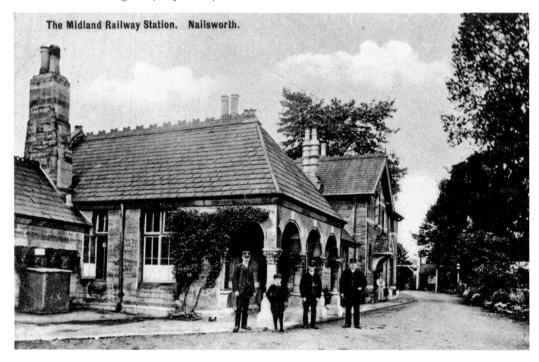

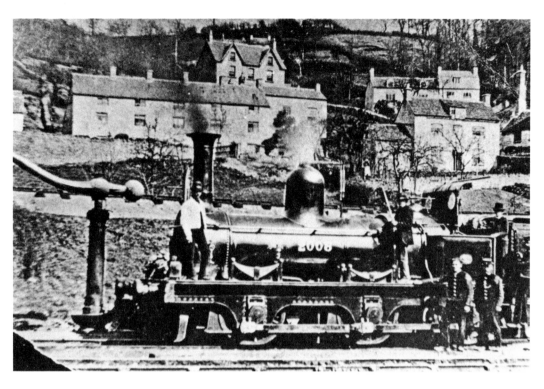

The Locomotive

The photograph of the locomotive, like its partner on the previous page, dates from 1873. Around 1905 Nailsworth photographer E. P. Conway reused it to create a postcard. Cottages at Watledge can be seen in the background. The present-day photograph was taken from Northfields Road, trees preventing any view from where the Victorian photographer stood lower down the hillside.

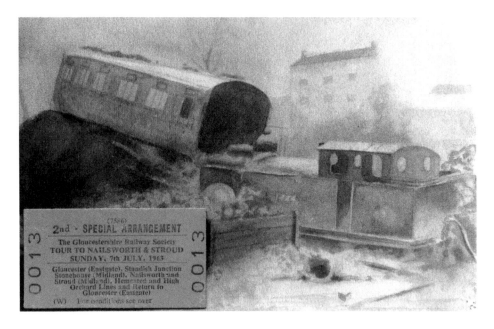

In the Station Yard

On Tuesday 16 January 1892, for no apparent reason, a train from Dudbridge failed to stop at the terminus in Nailsworth Station, ran on for 150 yards at full steam into the buffers and crashed down into the coal yard beyond. The impact knocked off the engine's funnel. Miraculously, passengers in the first coach escaped with nothing more than bruises. However, a young lady in the second coach suffered a broken leg and was taken to Stroud Hospital. It took three days to recover the locomotive. The scene shown here was painted by a member of the Benjamin family. The inset is a ticket for a special tour to Nailsworth in July 1963. The modern photograph is of C. W. Jones' former coal storage building, seen from the tranquil setting of Egypt Mill's terrace. The lettering on the warehouse was painted by Ann Makemson's late father, Ronald Woodward.

The Cross

The Subscription Rooms, opened in 1852, have served as a social centre for Nailsworth for more than a century and a half. During this time the building housed, variously, a Mechanics' Institute, a library, a cinema and a boys' club. Victoria Terrace beyond dates from the Golden Jubilee of 1887. The brick-built premises in the centre of the picture, the Wilts & Dorset Bank, replaced an earlier stone edifice. It was demolished to create easier access into Market Street. Two of Nailsworth's Edwardian pubs, The Crown and The King's Head, may be seen either side of Market Street.

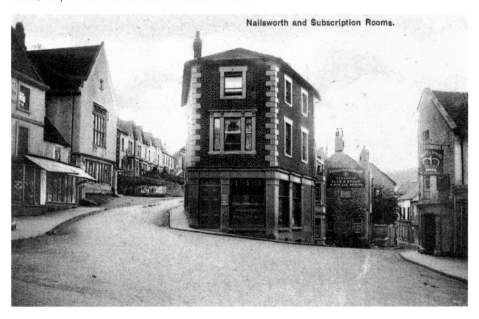

Nailsworth and Subscription Rooms.

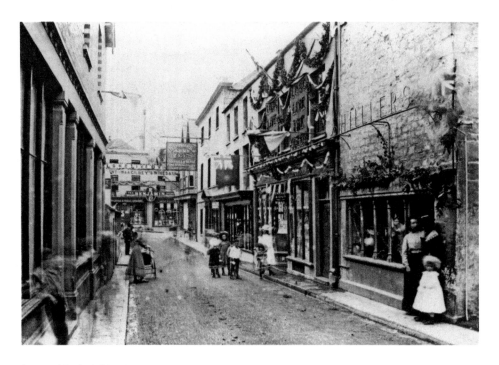

Lower Market Street

This busy street scene dates from 1897 and was probably the work of Paul Smith, resident in the town in the last decade of the nineteenth century. It was taken at the time of Queen Victoria's Diamond Jubilee, since when shops have been demolished, including the lavishly decorated one on the right, Lemuel Price's grocery store. This then gave access from the street through to Old Market.

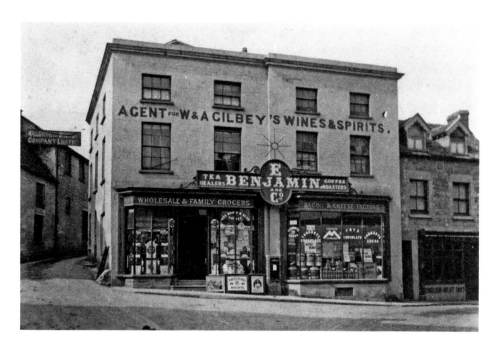

From Grocery to Charity

Edward Benjamin's firm was one of Nailsworth's principal grocery outlets a century ago. His brother, John, ran a similar business at The Cross, where his daughters later operated a small private school. The premises shown here were successively occupied at various times by a local Co-operative Society, a video store and, currently, by the Emmaus charity, which sells second-hand and refurbished goods to raise funds for the homeless. Emmaus Gloucestershire supports a community residence in the city; it also has shops there and in Cheltenham.

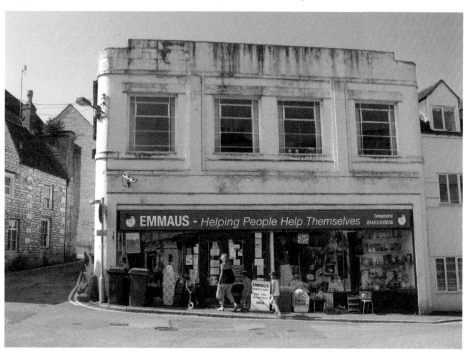

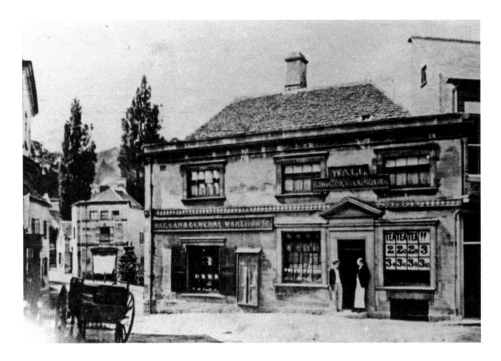

A Fine Building Survives

Today the combination of grocer and draper sounds curious, but this was not uncommon in the nineteenth century, from which period the splendid sepia photograph dates. It must be an early image, since Wall's firm last appears in the trade directory of 1874. The Nailsworth Archive, from which the picture comes, has only this slightly unfocused copy – one suspects the original was rather sharper. Demolition enables us to glimpse into Cossack Square through to Stokes Croft, perhaps Nailsworth's best-proportioned early eighteenth-century house.

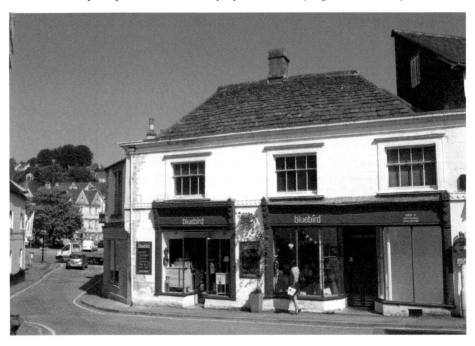

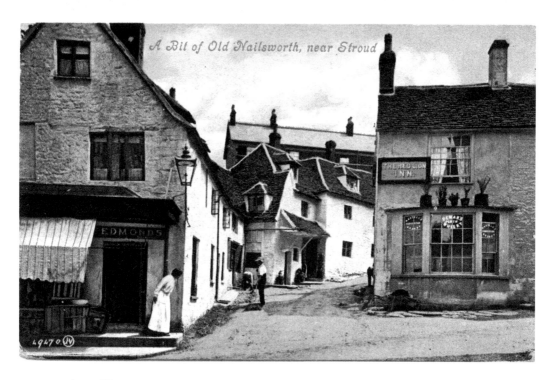

A Bit of Old Nailsworth, near Stroud

Butcher Hill's Lane

Finding period photographs of people at work – or, in this case, taking a break from work – is much harder than locating images of street scenes or landscapes. The information known about the sepia picture suggests that it dates from around 1906. Its coloured counterpart is, in fact, contemporary with it. The nationally published postcard was tinted by someone who clearly thought Cotswold tiles were orange! The lady is standing outside Edmond's flower shop. The porch in the lane is visible in both photographs.

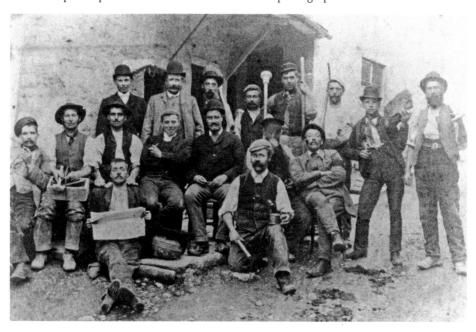

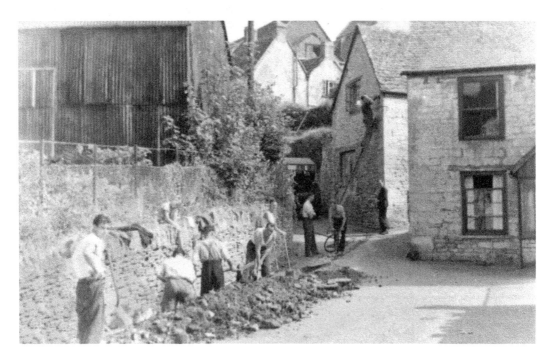

Brewery Lane

Road works took place in Brewery Lane in the 1940s and once again it is pleasing to find a picture of people at work. At this time the gabled building nearest in the background was the home of the Bathe family, who ran a chimney sweep's business. The inset shows Eddie Bathe with the tools of his trade. The modern image was taken on a warm June day when local residents were out enjoying the sun.

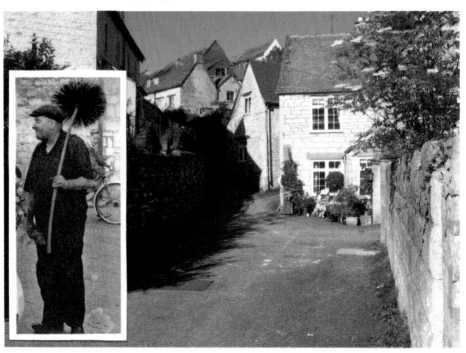

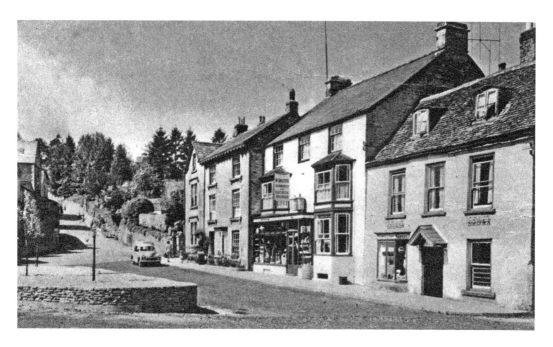

Cossack Square

Following the clearance of buildings in the centre of Cossack Square – notably Osborn Saunder's plumbing firm – the open area with which we are now familiar was formed. The premises on the far right, now Claire Frances' hairdressers, was formerly a baker's, run by the Allways, the author's grandmother's family. Next door was Bruton's, founded by Joseph Smith as a blacksmith's business in the mid-nineteenth century. Expanding into general hardware, Bruton's relocated round the corner in Old Market, once the road was opened up following the demolition of The New Inn.

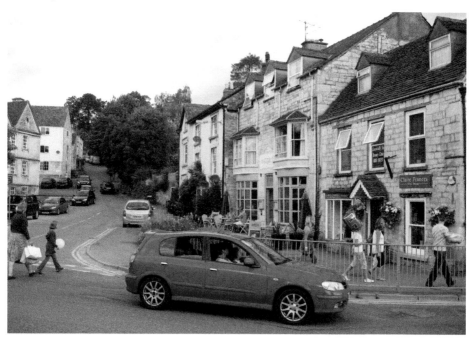

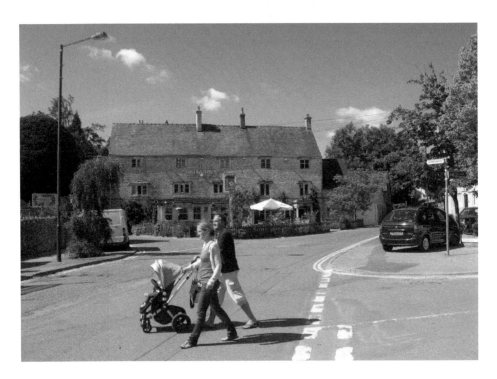

The Garage

Younger residents of Nailsworth would be surprised to see that commercial premises once abutted and – arguably – detracted from the classic Cotswold symmetry of Stokes Croft. Dickens' Motors first appears in a trade directory of 1931. Its entry says, 'JD Dickens, tours arranged, long or short periods. Engineers and garage proprietors, T.N. 68'. The sepia picture probably dates from the 1950s. The building on the left, The Steppes, has been run as an old people's home for many years, as was Stokes Croft for a time.

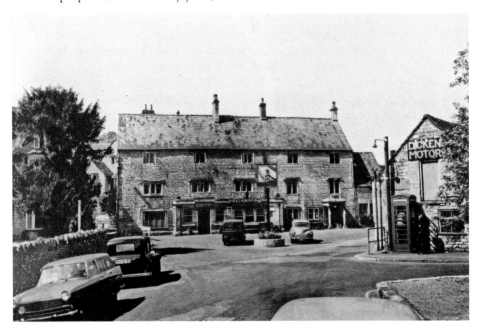

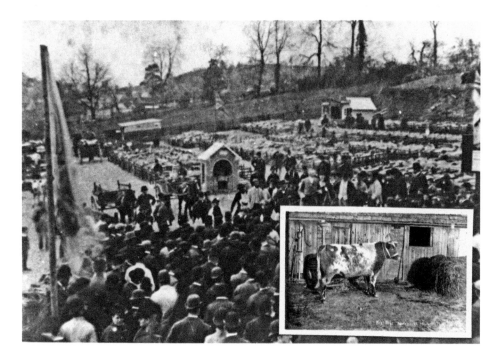

Old Market

From the late nineteenth century until its closure in 1931, Nailsworth Cattle Market was located in the area now known as 'Old Market'. It had originally been sited in 1865 at what is currently the George V Playing Field. Old Market is now one of Nailsworth's busiest areas, containing a row of shops, a supermarket, Bruton's store, two restaurants, the Bus Station, the Library and the Police Station. The modern picture shows the inception, in March 2008, of Old Market's latest development – Maple Tree Court housing for the elderly. The pair in hard hats are from the construction firm. The others are, from left to right, Betty Young, Allan Beale, Hazel Webb, Mary Blunt, Roy Close and Doris Highfield.

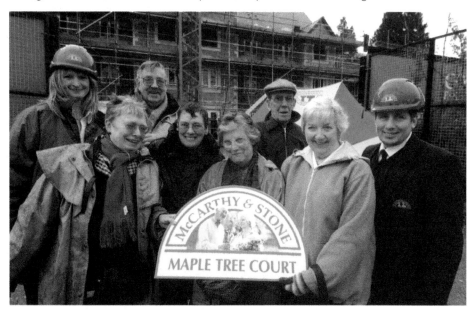

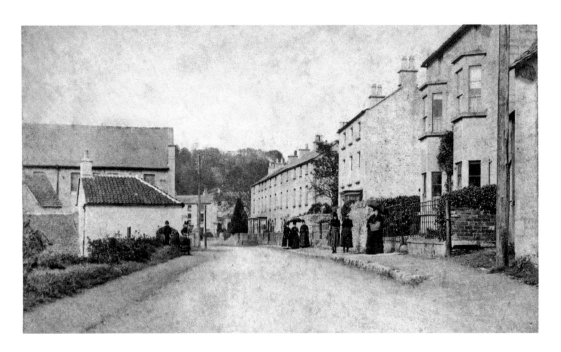

Bristol Road

Nailsworth is fortunate in that a good number of late-nineteenth-century photos of the town survive. In this view, ladies with parasols stroll along a decidedly uncluttered road. By contrast, the modern picture includes an array of telegraph poles, wires, road signs and double yellow lines. In the 1890s the Town Hall, on the left, was Nailsworth's breakaway Baptist Chapel, founded by a faction which had seceded from the mother church at Shortwood.

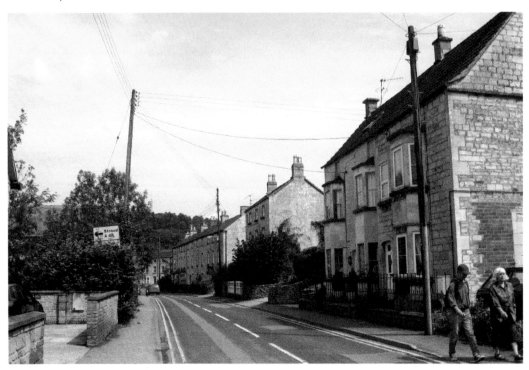

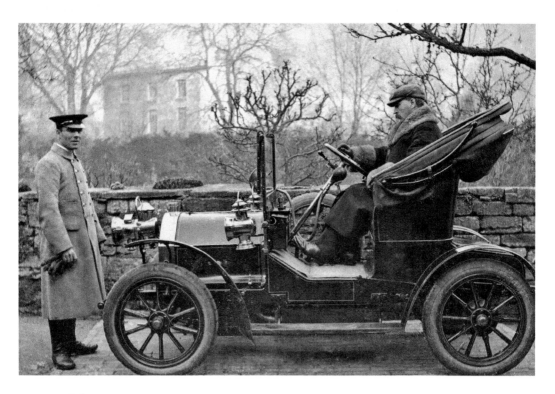

Medicine

The Edwardian photograph, taken near Egypt Mill Cottages by Amberley photographer H. Williams, shows Dr Robert Wilson, of George Street, in his early motor car. The man on the left is believed to be William Leonard. The picture is the only example of this photographer's work known to the author. The modern image is of the 1995 conversion work of Price's Mill into its present-day use as a surgery.

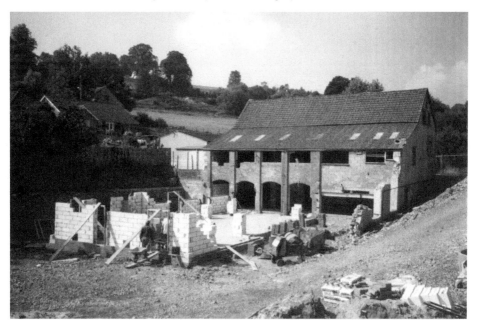

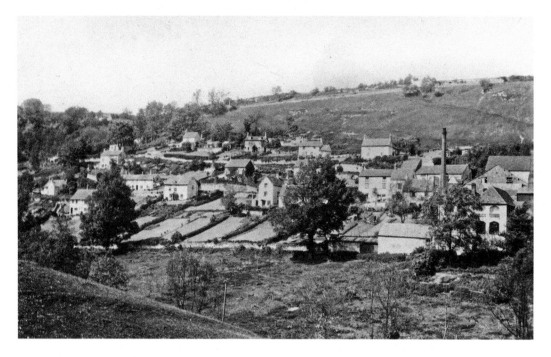

Newmarket

It is rarely possible today to take a picture from the exact spot where one was taken a century ago: approximations have to suffice. The right side of the earlier image is dominated by the extensive premises of Hillier's bacon factory. Most of the cottages on the left survive, around which more recent building development has taken place. Note also the modern housing along what was formerly an almost empty skyline.

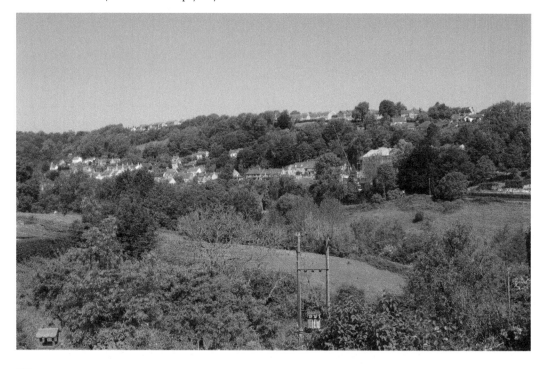

At The George, Newmarket

At a time when so many public houses are closing, it is good that The George is still such a central feature of life in Newmarket. Neither the building itself, nor the cottages beyond, have altered much over a century, although in the distance the former Newmarket Court has gone. It was replaced by industrial premises which, in turn, are now being superseded by a residential development, New Mills, comprising two-bedroom apartments.

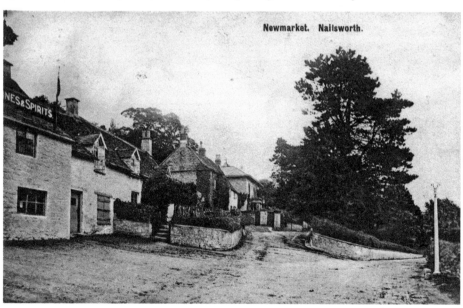

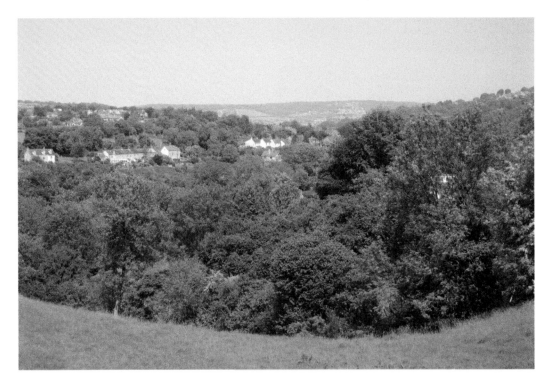

Rockness

The cottages at distant Rockness are visible in both pictures. However, once again trees obscure what the photographer of a century ago saw in the valley – Millbottom Mill (now Ruskin Mill) and Nailsworth in the distance. The earlier picture is a postcard view published by a nationwide company as part of the Kingsway Real Photographic Series.

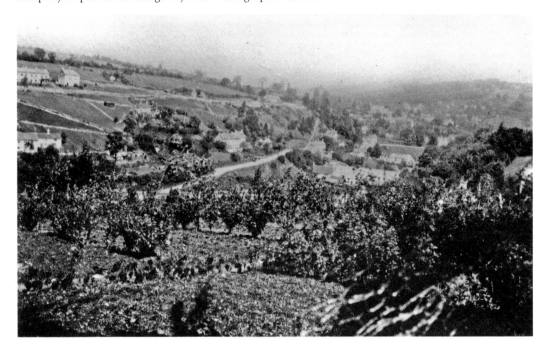

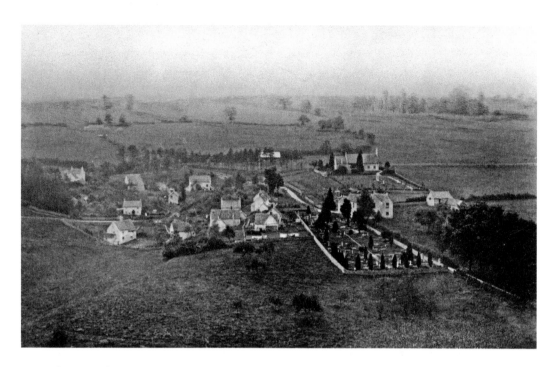

Shortwood

Another Kingsway postcard shows the historic centre of Shortwood hamlet, with its Anglican church, All Saints, put up in 1866. Below it on the hillside is the Baptist graveyard. The original chapel stood in its bottom right-hand corner. In the late eighteenth century, under its dynamic minister, Revd Benjamin Francis, Shortwood Chapel attracted one of the largest non-conformist congregations outside London. The modern picture is enhanced by a buttercup meadow in the foreground.

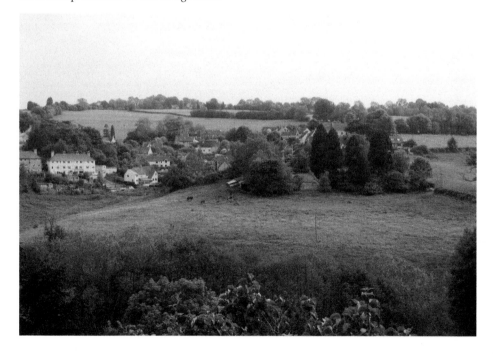

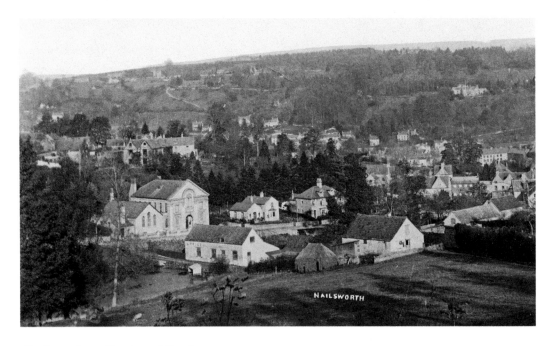

The Town from Shortwood Road

This is a classic view of the town, taken from a vantage point favoured by photographers since the 1880s. With Price's Mill in the centre foreground, behind is Christ Church (formerly the relocated Shortwood Baptist Chapel, opened on this site in 1881 and built with stone rescued from the demolition of the 1837 building further up the valley). A close comparison of the two pictures – almost 100 years apart – shows how much new housing development has taken place over this period. Again wild flowers provide an attractive foreground to the modern view.

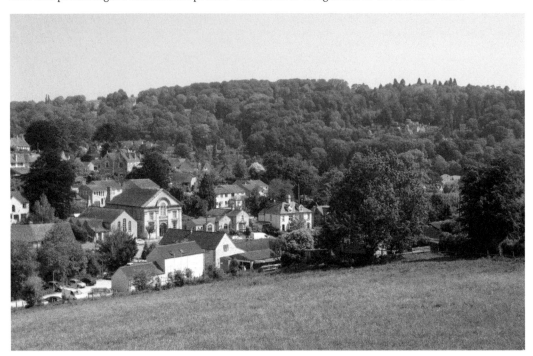

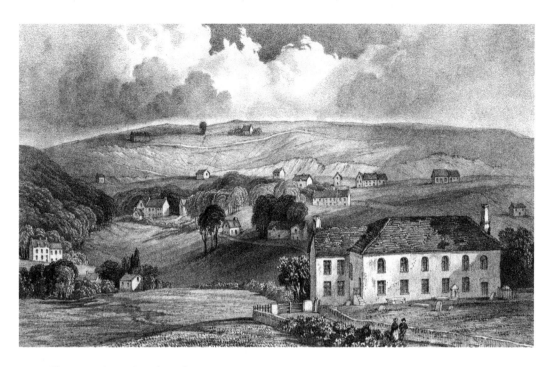

Shortwood Baptist Chapel

In this case 'then and now' means before and after 1837. The Baptists first broke away from Forest Green Independent Chapel in 1705 as a result of a series of sermons preached on infant baptism. They opened their own place of worship at Shortwood in 1715 which, in spite of several enlargements and eighty of the congregation emigrating in the 1830s, was deemed too small, so was radically rebuilt in 1837. The lower print shows the Victorian building which survived until the relocation to Newmarket Road in 1881.

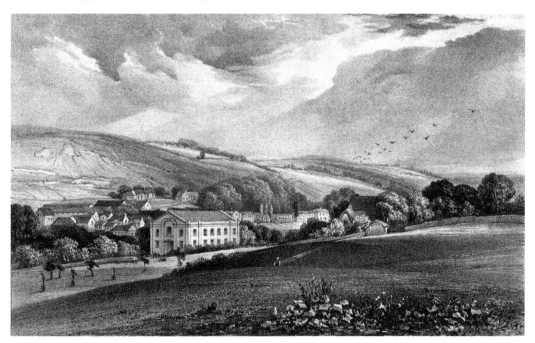

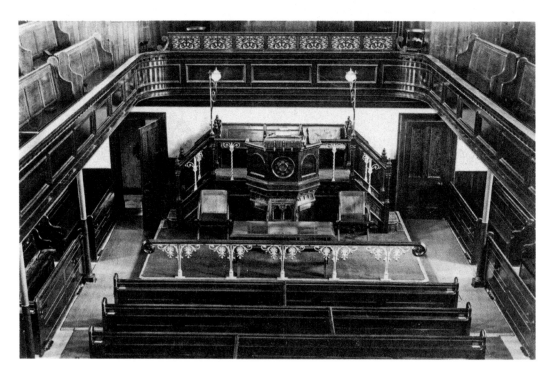

Christ Church Interior

The sepia picture is of the chapel interior just before 1900. Around and in front of the organ, just out of shot at the top of the photo, would have sat the choir, a body of some fifty singers – including members of the author's family – conducted by Mr Antill, who ran a china shop in Fountain Street. The modern photograph shows the rehearsal for the Cotswold Chorus recital of Beethoven's Mass in C on 10 July 2010.

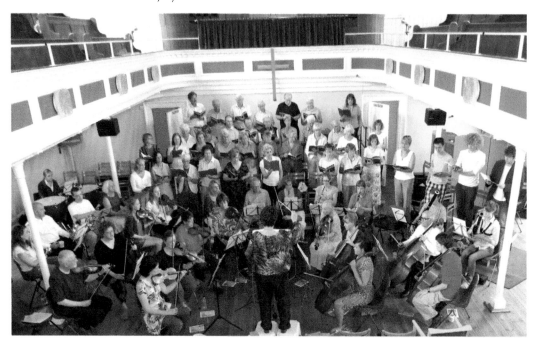

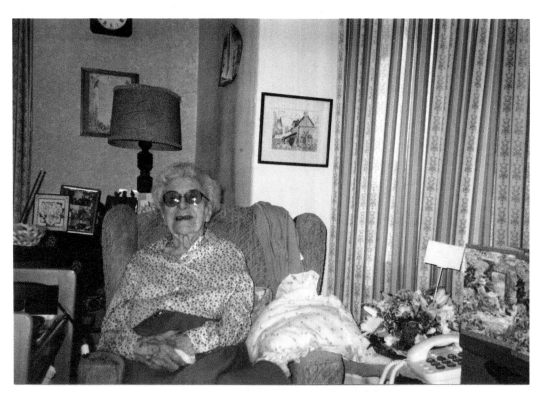

Winslow House

The house, formerly called 'The Lawn', is a finely proportioned building, much enlarged when it was adapted for its current purpose as a retirement home. At the time the author's mother occupied a room there in the 1980s, it was run by Mrs and the late Mr Peter Ashbee, seen in the photograph to the right. The picture above is of Mrs Lilian Day, a Winslow House resident, taken at the time she celebrated attaining her century on 30 June 2002 – she lived a further two years.

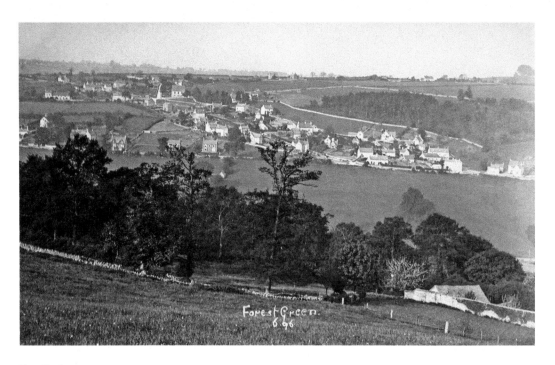

Forest Green

The modern picture here is taken from across the Nailsworth Valley at Pinfarthings – from a spot as close as is possible to that chosen by the 1906 photographer. This sepia image is particularly clear and well-focused. Its present-day equivalent shows just how much Forest Green has been developed over the years. In the earlier view, note the upper of the two Congregational chapels – both now demolished – which stood close to the graveyard.

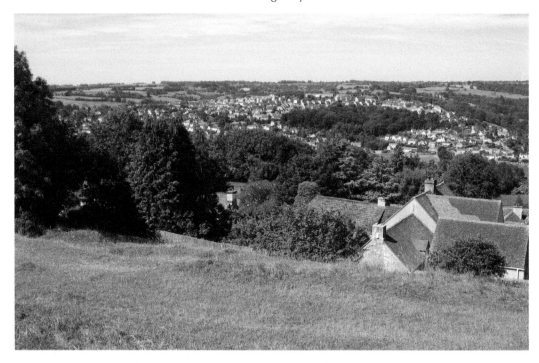

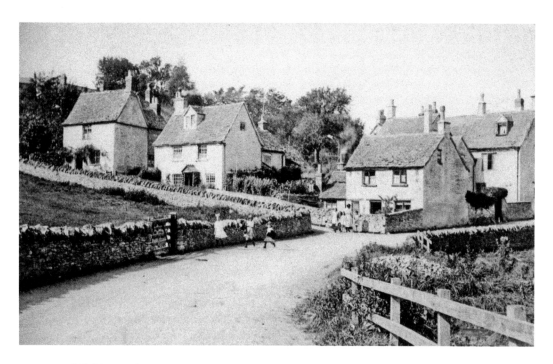

Northfields Road

The houses on the left in the modern view have been put up since the sepia photo was taken around 1905. One of the cottages on the right has also been enlarged. In taking the modern photograph it is often impossible to avoid overhead wires and pylons, as this example shows. From observing the shadows it would seem that the two pictures were taken at a similar time of day.

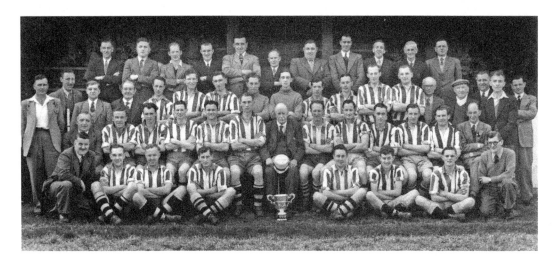

Forest Green Rovers Football Club

The club was founded in 1889, its creation inspired by the enthusiasm of the local Congregational minister. In 1894 Rovers became founder members of the Mid Gloucestershire League and, in 1902, joined the newly formed Stroud League. Space prevents a full history of Rovers from being included here, but this may be obtained on their website. Suffice it to say that glory came towards the end of the twentieth century and involved appearances at Wembley in 1982 and 1999. The black and white picture is of the team and officials in the 1950/51 season. The later image was taken when Rovers played Derby County at home on 3 January 2009 in the FA Cup third round. This was the biggest game in the club's history and saw a capacity crowd at The New Lawn. FGR lost 4-3 in a memorable thriller.

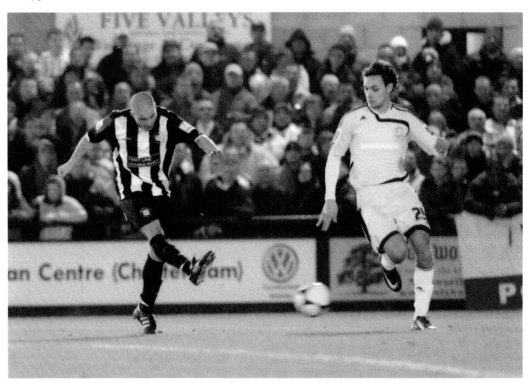

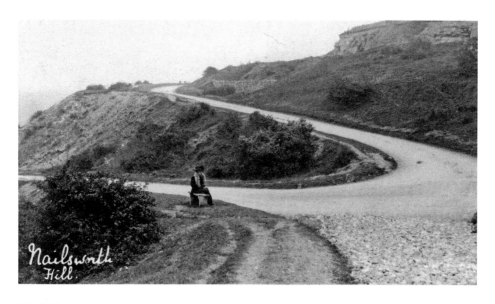

The 'W'

Many photographers have taken pictures at this spot, but how it has altered! Note the quarry, top right. Today we would call this road the 'W' but, at the time the poet W. H. Davies was resident in Nailsworth, it was equally well known by its earlier name, as his celebrated poem, 'Nailsworth Hill' reminds us:

> *The moon that peeped as she came up*
> *Is clear on top, with all her light;*
> *She rests her chin on Nailsworth Hill*
> *And, where she looks, the world is white.*
>
> *White with her light – or is it frost,*
> *Or is it snow her eyes have seen;*
> *Or is it cherry blossom there,*
> *Where no such trees have ever been?*

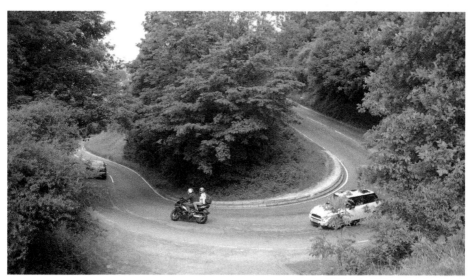

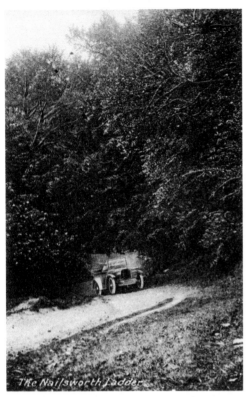

The Nailsworth Ladder

The Ladder

Before the 'W' was created two centuries ago, the steep track called The Ladder was the only direct way from Nailsworth up to Minchinhampton Common. For the last hundred years or so it has been used for motor-car and motorcycle trials. The Ladder is fringed with beech trees, which makes it especially attractive in autumn.

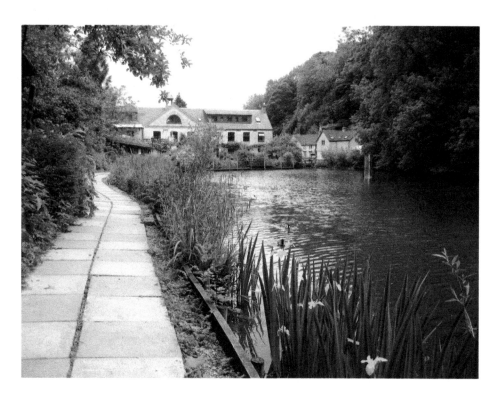

Ruskin Mill

Millbottom Mill was a corn mill in 1564. A century later it was owned by Edward Webb, a clothier. A fulling mill and dye house were added on a few years afterwards. It continued, however, to be worked as a corn mill for most of its history. It was acquired by the Gordon family in 1968, renamed Ruskin Mill and has since been developed into a successful Further Education Centre for young people. The valley and ponds upstream have been beautifully and sensitively landscaped.

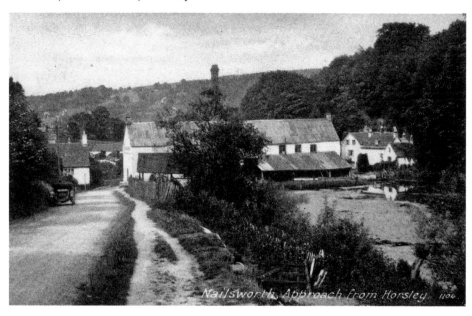

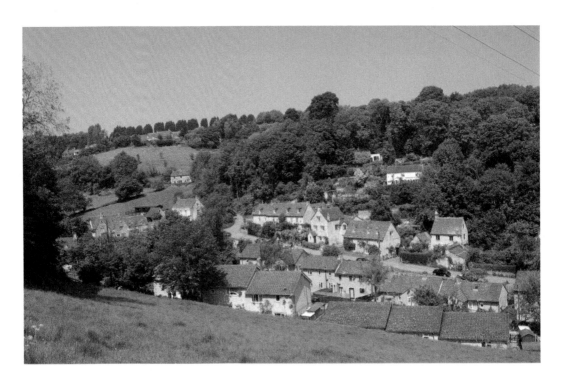

Downend

The sepia image came from E. P. Conway's camera and was taken in or around 1905. Its 2010 equivalent pinpoints clearly where modern building has taken place, especially on the nearside of the road. The contrast between the two pictures is further highlighted by the opposing seasons in which they were taken.

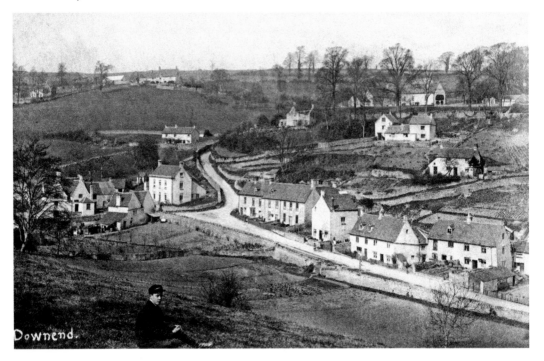

Downend.

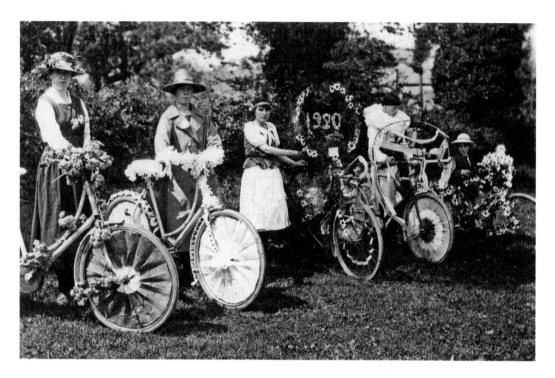

Two-wheeled Transport

The colour photo shows a fantastically conceived, bicycle-powered vehicle which took part in the town carnival in April 2007. Its earlier counterpart depicts an event of 1920. The eighteen-year-old girl in the white skirt is the author's mother, Vera Lee, who maintained to the end of her long life that the reason she didn't win the decorated bicycle competition was because she was 'Chapel' and the judge was an Anglican!

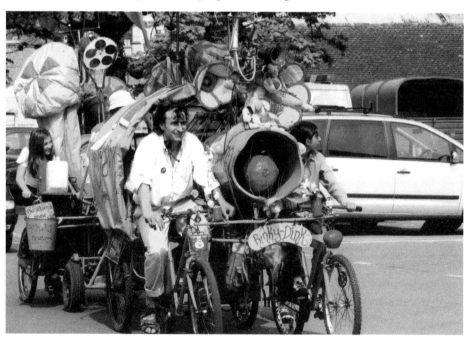

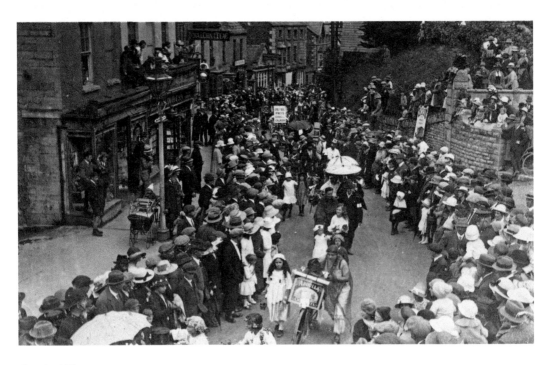

Carnival Time

The period picture, probably also dating from 1920 or thereabouts, was taken from an upstairs window in the Wilts & Dorset Bank. In the foreground a person in oriental costume promotes Abdullah cigarettes. Note the onlookers perched on the ledge above W. H. Smith's shop on the left. The modern picture is of a matching procession during the Nailsworth Festival in April 2004.

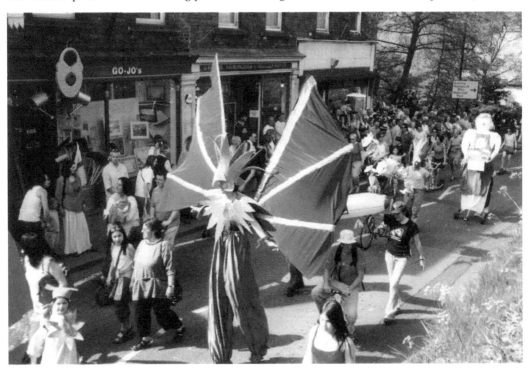

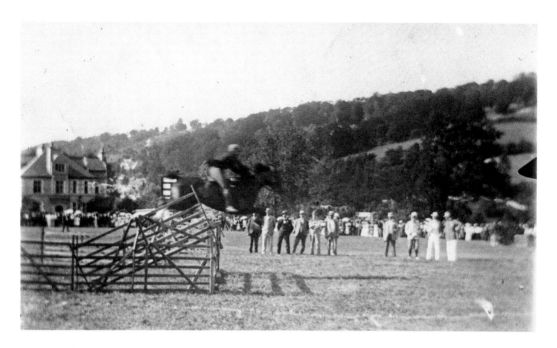

On the Playing Fields

In the summer of 1926 the Nailsworth Horse Show took place on the King George V Playing Field, previously known as 'The Enochs'. The picture chosen is somewhat blurred through the action of horse and rider. The modern photograph was taken in June 2010 during the Nailsworth Games, and the inset image dates from 1999.

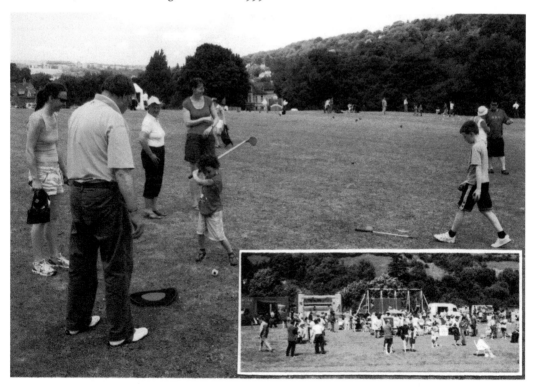

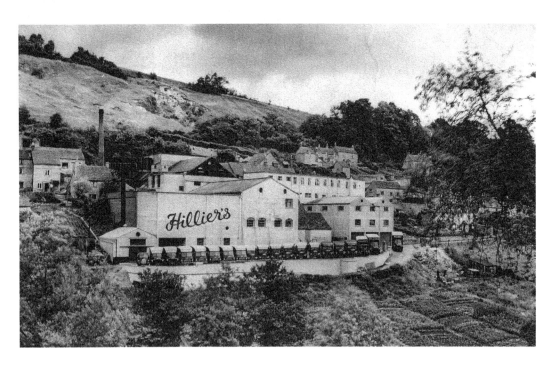

Hillier's

Born in 1797, Isaac Hillier was arguably Nailsworth's most successful businessman ever. While still in his teens he ran a stall in Market Street. Marriage to a mill owner's daughter, Martha Playne, did him no harm and by his mid-thirties he had moved up the valley and owned Newmarket House. His bacon-curing firm eventually occupied most of the north side of the valley. Isaac died in 1886, but his business continued for a further century. The upper picture shows the factory fifty years or so ago and the lower one its demolition in 1993.

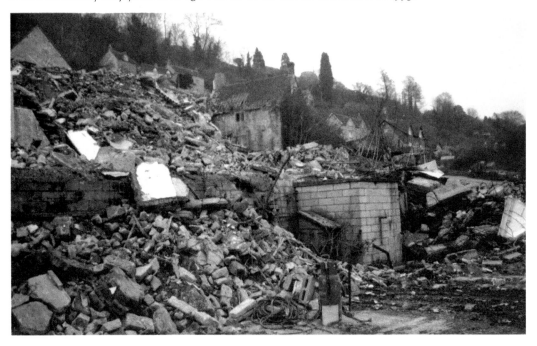

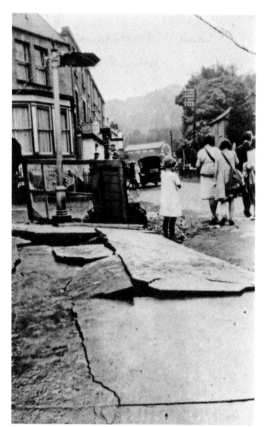

Floods

August 1931 saw the most serious flood in Nailsworth's history. Although no one was killed, extensive damage to property occurred. The event is described more fully in *Nailsworth in Retrospect*, published in 2000. The summer of 2007 witnessed another severe flood, although thankfully less damage ensued. The colour photograph indicates the extent of the deluge in Old Market.

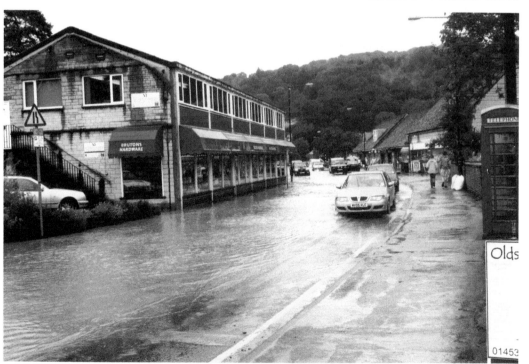

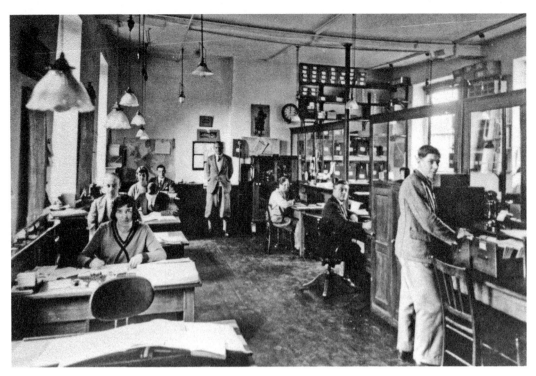

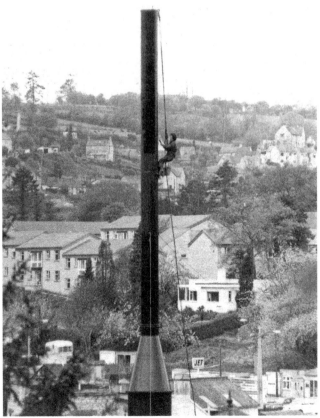

Chamberlain's

In 1879 E. A. Chamberlain acquired Nailsworth Mill in George Street, where he developed his leather board factory. The business prospered and was for many years one of the town's principal sources of employment. In 1930 a professional photographer was commissioned to record the premises prior to the preparation of a booklet about the firm. The picture of the main office is reproduced by kind permission of Mr Chris Chamberlain. The later photo shows the factory chimney being painted in 1974. Morrison's supermarket now occupies this site.

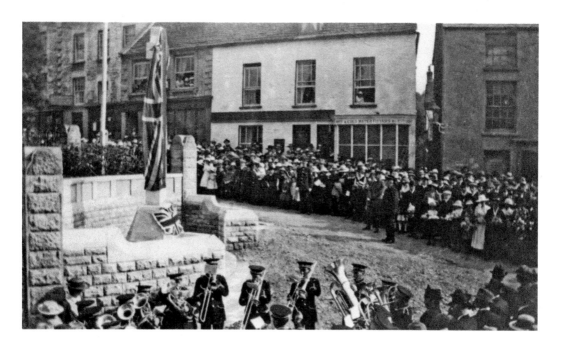

Remembrance Day

At the end of the First World War memorials to the fallen were unveiled throughout the country. The sepia picture shows the ceremony at Nailsworth. It is difficult, perhaps, for us today to imagine how poignant such occasions must have been. Everyone in the crowd inevitably knew several of those named on the monument – perhaps even witnessed the arrival of the telegram bearing the sad news, as did the author's grandfather, F. W. Lee, who was in a Nailsworth house delivering clothing from his Bridge Street shop when the knock came on the door. The modern picture shows Remembrance Sunday 2006.

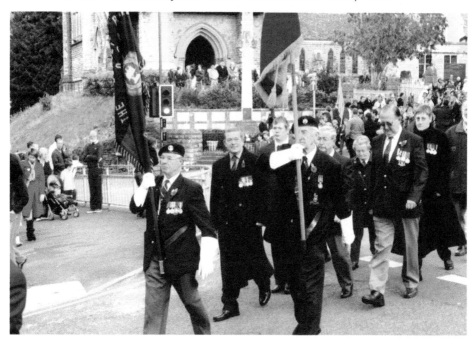

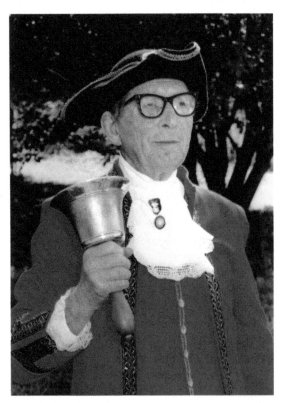

Oyez, Oyez

In 1852 a certain Tony Teakle was apparently Nailsworth's Town Crier. In the Queen's Silver Jubilee year, 1977, the late Victor May was appointed to the re-created post. A member of a well-known local family, he quickly endeared himself to the town through his service to the community in the Ancient and Honourable Guild of Town Criers. In 1984 Victor represented Nailsworth at the Guild's World Competition in Canada, where he won a trophy for 'Most Convivial Town Crier'. Tony Evans is the current town crier in Nailsworth. He is seen here as he appears on a postcard (which includes the clock and the town's coat of arms) available at the Tourist Information Office in George Street.

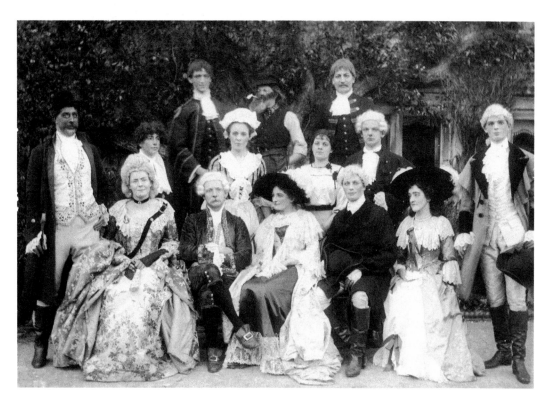

Amateur Dramatics

The early photograph of around 1915 shows a production of a period drama by Miss Agnes Newman's group. The title of the play is not known, but a message on the back of the image records the 'grateful thanks of the Nailsworth Amateur Dramatic Society to Mr F. B. Newman', perhaps for the loan of rehearsal rooms. The colour picture is of the pantomime *Dick Whittington*, staged by the Society in January 2008.

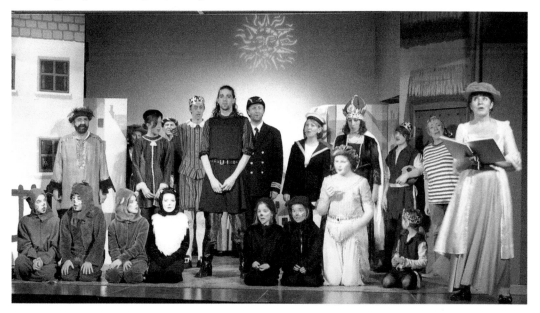

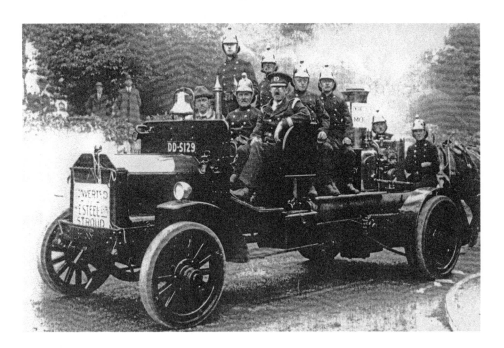

The Fire Service

Like most small towns, Nailsworth in the nineteenth century owned hand-pumped, horse-drawn engines. Around 1900 parishes often acquired Merryweather steam-powered (but still horse-drawn) machines. Stroud owned two examples of these, of which some very splendid pictures survive. By 1924, as the upper photograph shows, the Nailsworth and Woodchester Valley Volunteer Fire Brigade owned a fully motorised vehicle. In the present-day image a tender is washed down at the Fire Station in Station Road. Previously engines were housed at Old Market.

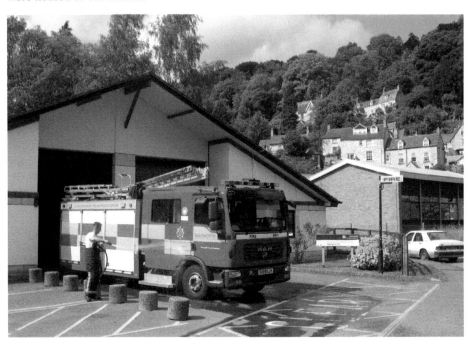

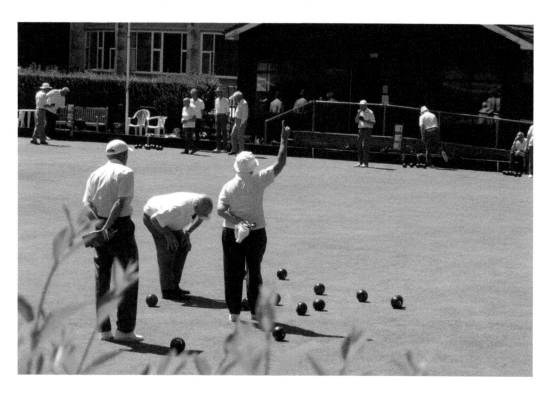

Bowls

Bowls in Nailsworth started in 1900 on a green behind the George Hotel. As mentioned earlier, the author's great-grandfather, Stephen Beard of Forest Green (1839–1925), worked at this time as gardener at the George and was very probably responsible for mowing the turf there. In 1924 Mr E. A. Chamberlain funded the club's new premises next to his factory off the Avening Road. Thanks to the kindness of Mrs Pat Buckenham the modern picture was taken in the summer of 2010.

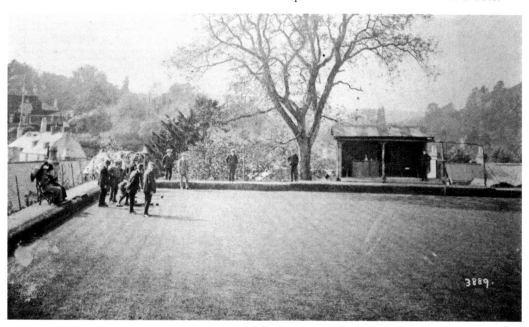

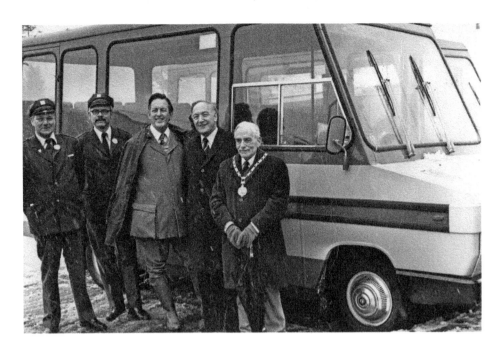

George and Betty Mills

The names of Mr and Mrs George Mills are inextricably woven into the story of Nailsworth during the second half of the twentieth century. George was involved in a range of activities in the town, but is particularly remembered for his work as a councillor. He is pictured here inaugurating Nailsworth's first minibus service in 1979. A native of Scotland, Betty was first married to Sidney Newman of Newmarket, who died in 1971. In the course of her own council work she met George and became his wife in 1976. Through inheriting the Newman family papers, Betty became fascinated by Nailsworth's past and, in 1985, wrote her history of the town, *A Portrait of Nailsworth*. The lower picture shows her in June 2003, unveiling at the Library the ceramic wall plaque dedicated to her late husband and designed by Kerry Von Shoek.

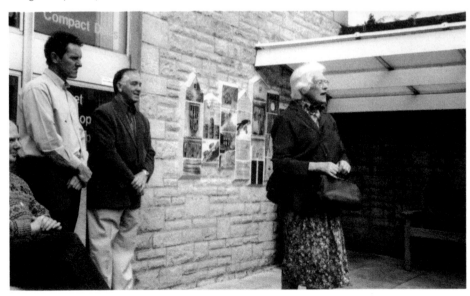

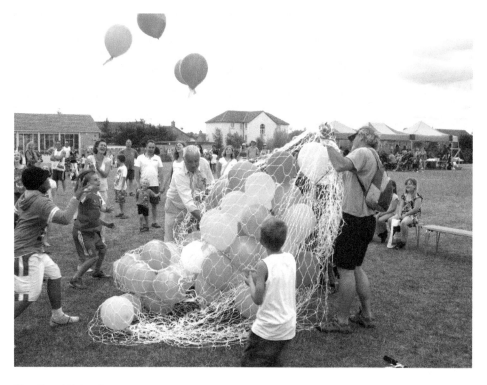

The Boys' School

This British Boys' School photo of 1930 includes many well-known Nailsworth characters, including businessman and artist Brian Davis (back row, sixth from left) and Douglas Drake (middle row, third from left). It was housed in a building at the top of Spring Hill and later became Nailsworth Primary School. It is now private housing. The modern picture was taken at the school's summer fête at its current site in Nympsfield Road in July 2010. It shows the Head Teacher and the Mayor, Stephen Robinson, assisting in the balloon release.

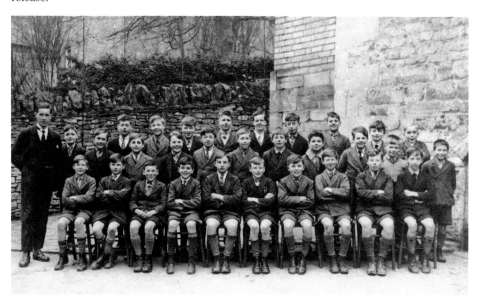

WOODCHESTER

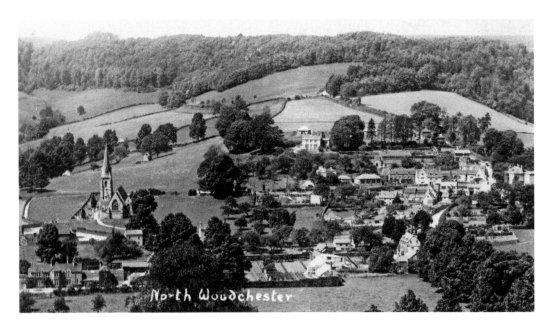

North Woodchester

The earlier picture of North Woodchester was taken around 1930 by local semi-professional photographer W. H. Adams. William Adams' work involved visiting local post offices and, on his travels around the district, he took the opportunity to capture views of the area, which were subsequently turned into postcards. The spot chosen from which to take the pictures on this page was close to one of the greens of the old Stroud Golf Club on Rodborough Common.

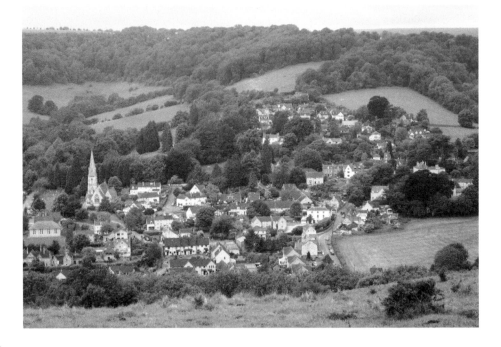

Rooksmoor

This low-lying area has always been subject to flooding. According to information available, the lower picture was taken in the mid-1960s. The Fleece Inn is a long-established hostelry, with an excellent reputation for its cuisine. The pub is currently owned by a group which also runs The Britannia and Tipputs Inn at Nailsworth, The Old Lodge on Minchinhampton Common and The Foston's Ash Inn along the road to Birdlip.

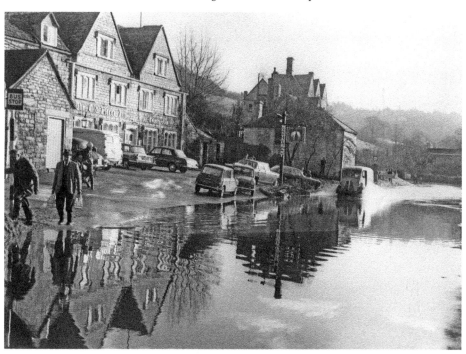

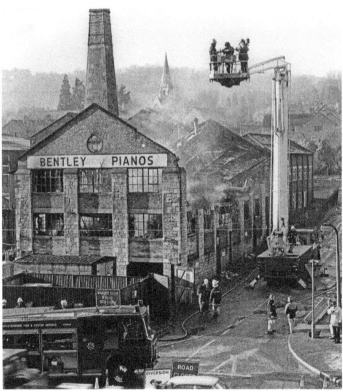

The Piano Works

Douglas Grover began manufacturing pianos at Woodchester in 1911, bringing with him ten key workers from London to form the Stroud Piano Company Limited. In the 1930s the name Bentley was chosen for a new range of instruments. Fires in 1938 and 1977 caused major disruption. The picture to the left is of the most serious blaze of all, in 1989. However, rebuilding once again took place. The Grover family sold the business in 1994, but pianos continued to be made on the site until final closure in 2003. Various firms now occupy the building.

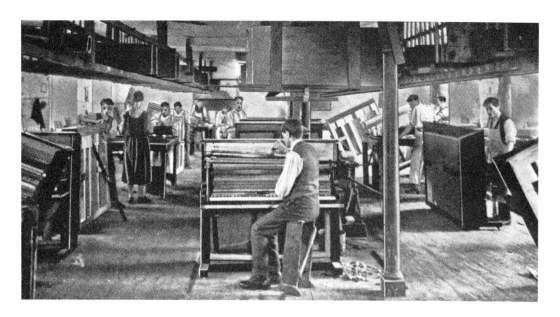

The Pianos

The black and white picture is taken from the piano company's 1927 sales brochure. It is a curious image – at first glance a photograph, although on closer inspection many of the characters appear to have been at least partially painted in! The Art Deco advertisement inset is from a catalogue of around 1933 and the larger colour picture shows the 'Woodchester' model produced by the re-established company in 1994.

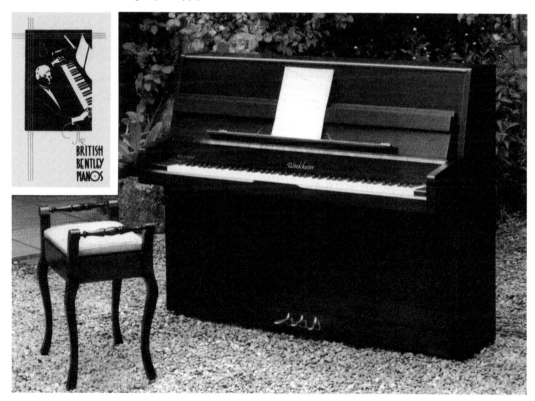

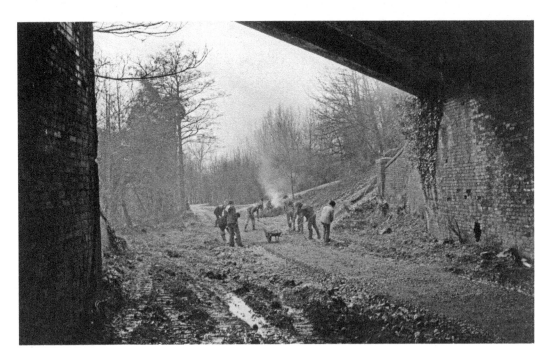

The Cycle Track

The Stonehouse to Nailsworth branch line of the old Midland Railway lay derelict for many years after the last train ran in the 1960s. By the 1980s a decision had been made to turn it into a cycle track connecting Stroud with Nailsworth. The earlier picture shows clearance work taking place along the line at Frogmarsh in February 1984. Today the cycle track is effectively a kind of linear park, used mainly by cyclists, ramblers and dog-walkers. In the modern image, a cyclist pauses by a particularly interesting example of tunnel graffiti.

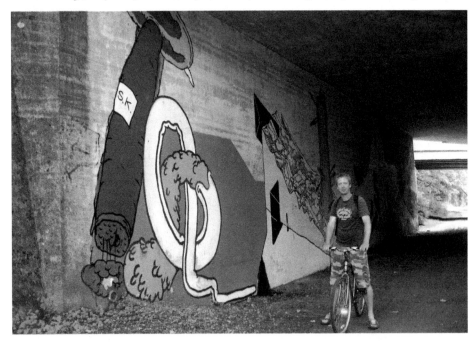

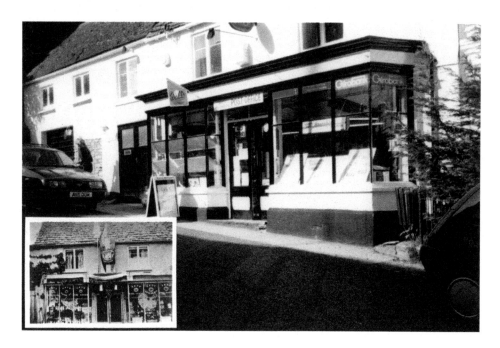

North Woodchester Post Office

The inset – a rather poorly focused image – is of the Post Office decorated for Queen Victoria's Diamond Jubilee in 1897. The upper picture is a photograph of the premises as they were in 1990. As the present-day image shows, the business has now moved into what was formerly the garage end of the building. This Post Office has happily survived the current national spate of closures.

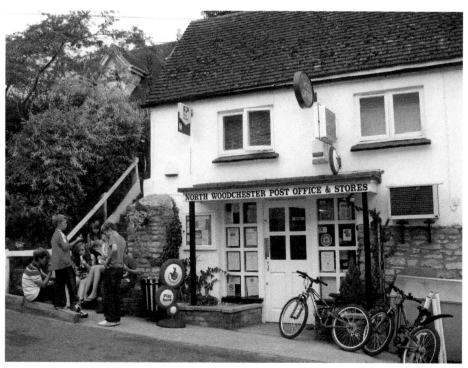

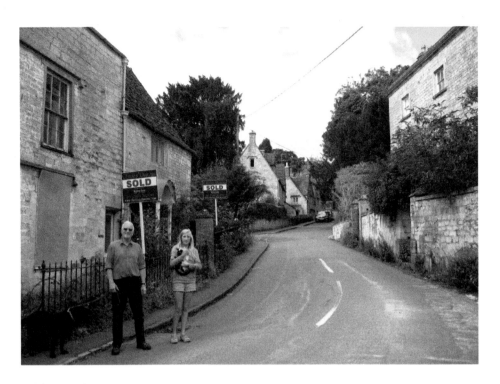

Selsley Road

The black and white picture, again by William Adams, dates from the 1920s or 1930s. It shows buildings further up Selsley Road from the Post Office. The ivy-covered houses on the left were sold in July 2010 as part of an extensive property portfolio. A window has been inserted into the rebuilt cottage in the middle distance. The large edifice on the right is called The Lawn. In the modern view, Rod Harris, who lives a little further up the road, poses with his daughter Ruth and dog Meg. The cat which Ruth is holding happened to be passing by and seemed willing to be part of the photograph!

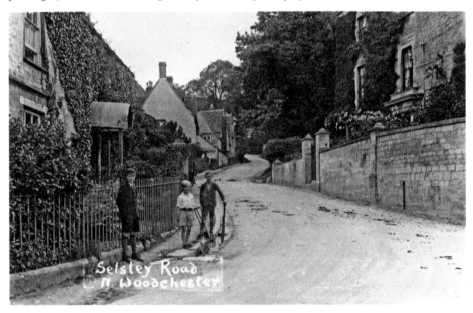

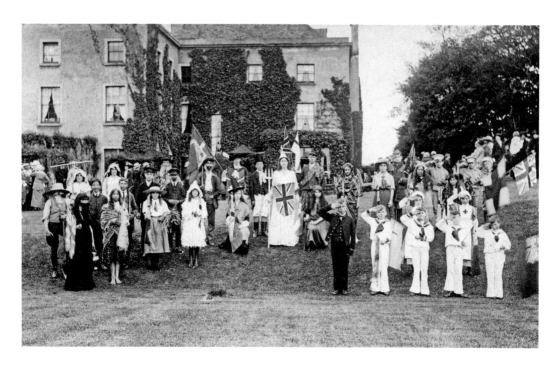

The Lawn

When he was MP for the Stroud Division in the 1890s, J. Brynmor Jones lived at The Lawn.
In 1910 it was the home of retired clergyman Revd Thomas Aikin-Sneath. The sepia picture
shows an event taking place in the grounds – almost certainly Empire Day celebrations, since
the children are dressed in costumes from various parts of the world. The date is thought
to be around 1914. Note the ivy on the walls, then believed to enhance the appearance of
buildings. The modern photo shows how little the house has altered structurally.

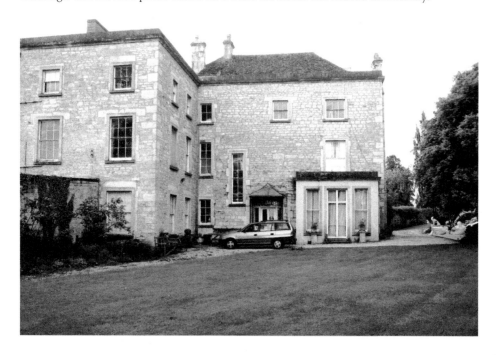

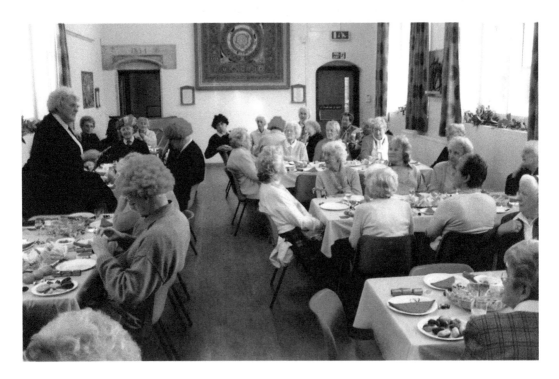

A Place to Meet

Before the Second World War, the YMCA Recreation Hut was one of the main meeting venues for the village. The hut stood on the north side of Selsley Road, just on the topside of what is now the cycle track. It was burnt down during the war. The modern picture is of the interior of the Village Hall, situated near The Royal Oak in North Woodchester, and shows the Friendly Circle enjoying a recent Christmas party.

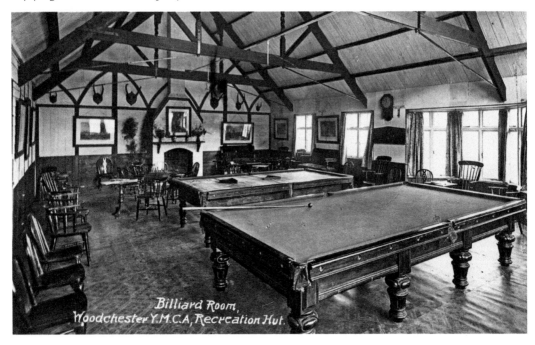

Billiard Room, Woodchester Y.M.C.A. Recreation Hut.

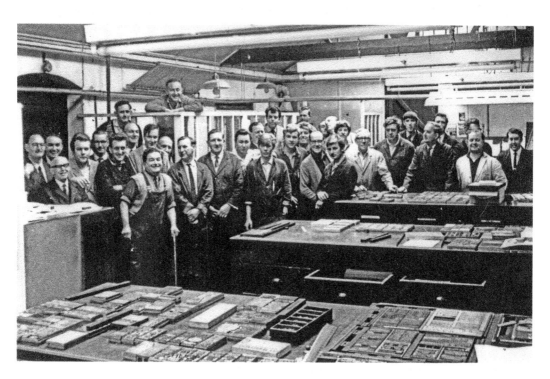

Arthur's Press

Arthur's Press is a name familiar to most local people. This successful printing business was founded at Vale Mills around 1930. When the photograph of the workforce was taken, in the 1960s, the company clearly employed a sizeable staff, seen here in the composing room. The bottom picture was taken in October 1985, after the closure of the business, and shows the site being developed for housing.

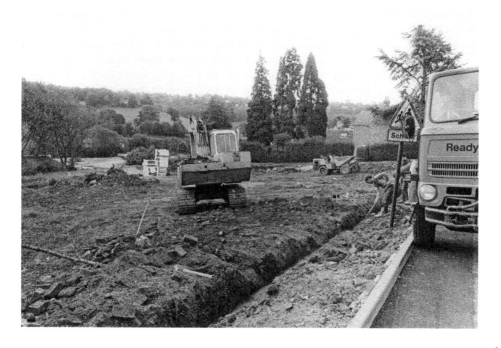

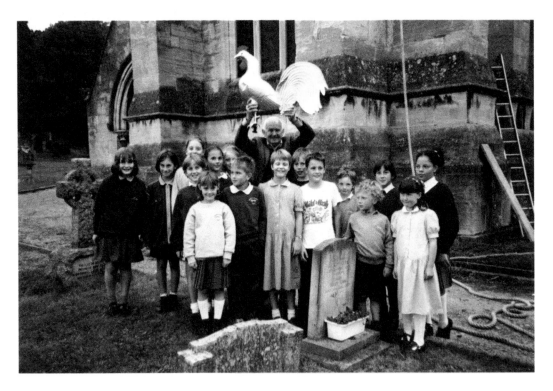

St Mary's Church

By the mid-nineteenth century the old church on the Roman Villa site – of which more later – was considered too small, so the present building, on a site more central to the parish, was erected. It was consecrated on 24 September 1863. The architect was S. S. Teulon (1812–73). The spire is 123 feet high. In the 1997 photograph, Lance Cordwell, accompanied by a group of local children, is pictured with the cockerel about to be replaced on it.

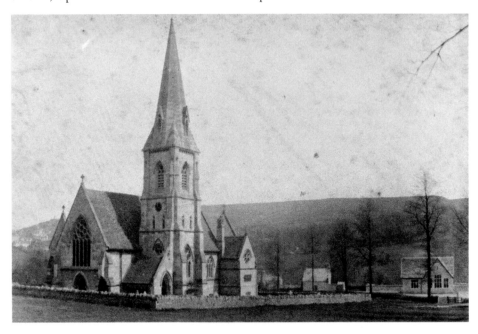

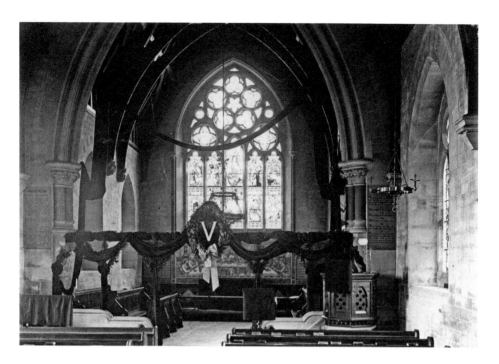

St Mary's Church Interior

The sepia picture is of the east end of the church and is of considerable importance, since it shows the chancel decorated in black following the death of Queen Victoria in January 1901. The rood screen was put up just a couple of years later and, as the inscription on it proves, celebrates the coronation of Edward VII. It was given by the Workman family and made in their factory in the parish.

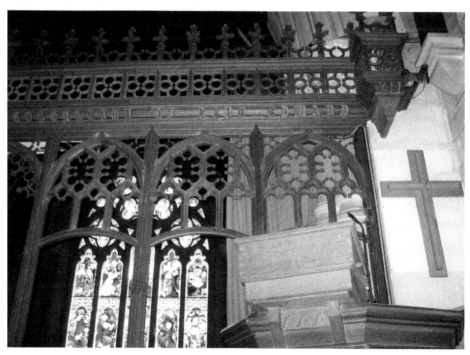

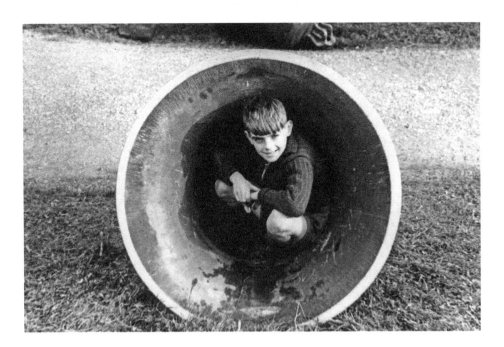

Bells

St Mary's has a peal of six bells transferred from the old church and rehung. One dates from the fourteenth century, three from the eighteenth century – made by the Gloucester firm of Rudhall – and two were recast in 1956 by the Whitechapel Bell Foundry in London. The earlier picture of the child, taken in that year, shows the size of the mouth of one of the bells. Woodchester has also had a successful group of handbell ringers. The 1994 image shows, from left to right, Bob Barter, Diana Fowler, Vivian Deane, Bill Brunt and Kathryn Deane. Diana has been responsible for much valuable work preserving, copying, collating and storing an excellent collection of period photographs and documents concerning Woodchester.

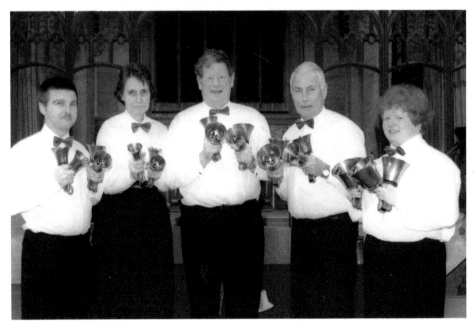

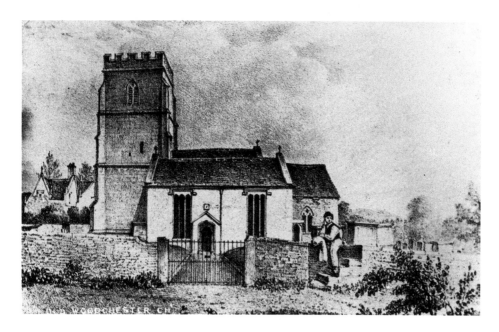

The Old Church

It is possible that there was a priest at Woodchester in the late ninth century; certainly a building existed on the villa site by the twelfth century. When most of the old church was demolished in the 1860s, a portion was left standing and remains to the present day. Several monuments were moved to the new site, including a sixteenth-century cenotaph for Sir George and Lady Huntley. Another commemorates George Onesiphorus Paul, of prison reform fame. In the modern photograph the area behind the fine Cambridge family tomb is where the celebrated Roman mosaic lies buried.

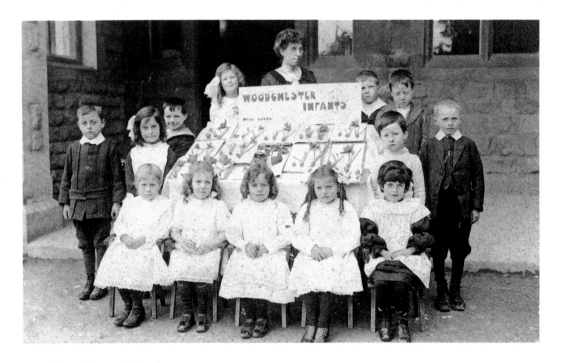

Woodchester School

The present Endowed C of E School buildings were put up in 1888, the cost defrayed partly by selling off the earlier 1834 structure and partly by subscription. The charming 1914 photograph depicts a group of infants with the results, apparently, of a nature study project on display. The colour picture, kindly supplied by Gordon Soutar, the Head Teacher, dates from October 2009 when the school explored the theme of 'Space'.

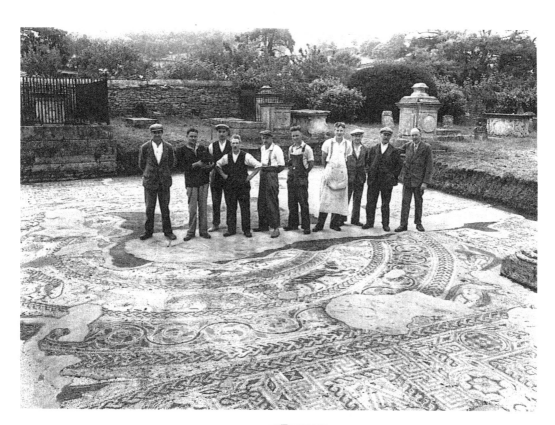

The Orpheus Mosaic

Said to be the largest and finest north of the Alps, the Great Orpheus Mosaic was first fully exposed in 1797 when Samuel Lysons excavated the extensive villa of which it is a focal part. It was re-opened in 1880, 1926, 1935, 1951, 1963 and 1973. The Woodward brothers worked for over ten years to construct a full size replica of the Mosaic in moveable sections; this has recently been sold (June 2010) to a mystery buyer – hopefully it will stay in the area. The black and white picture was lent with no accompanying information, but presumably shows those who uncovered the pavement – possibly in 1951. The 1993 colour photograph is of the late Bill Brunt dressed as a Governor of Roman Britain. Bill assembled a large collection of photographs of Woodchester, now in the parish archive.

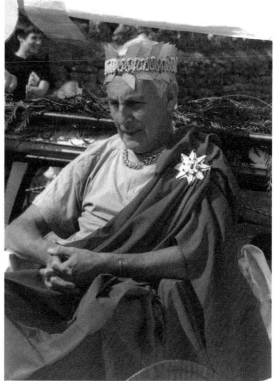

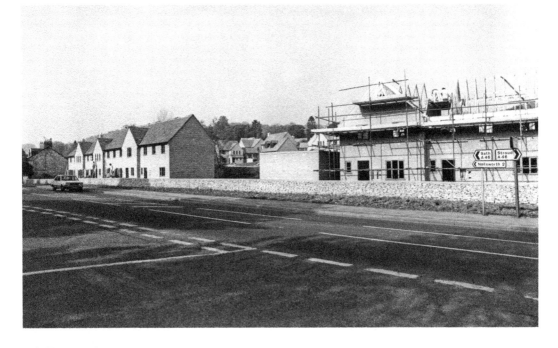

Building Development

Mention was made earlier of building development on the site of the former Arthur's Press. Other projects in recent years include Paul's Rise, Manor Gardens and, pictured here under construction in September 1987, Millpond End, just off the A46. During an earlier period Berryfield had been built. Also numerous individual houses have been erected, as distant views of both North and South Woodchester make clear.

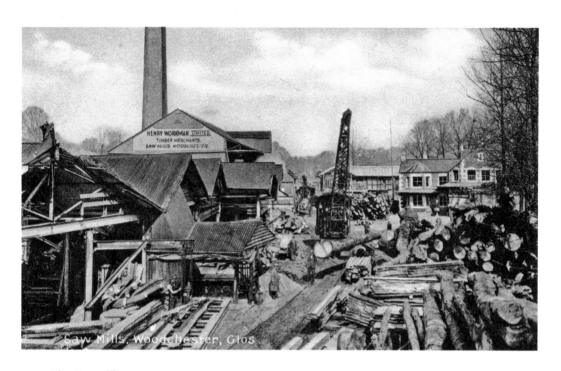

The Sawmill

Woodchester Sawmill was founded in the nineteenth century by Henry Workman, who died in 1924. In 1870 the firm moved to the premises shown on this page – just across the A46 from where Denis Brown & Son's timber business is today. Workman's suffered several fires, the most severe in 1911. The lower picture shows Henry (in the straw boater) inspecting the damage. The Edwardian image at the top indicates the extent and importance of this firm, which finally closed in 1957.

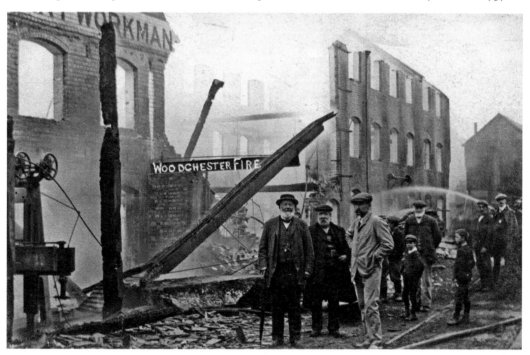

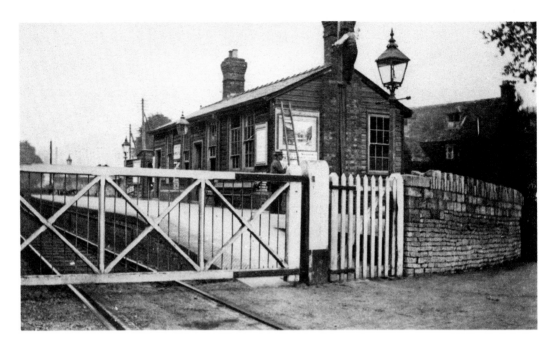

The Station

Woodchester was first served by rail when the line from Nailsworth to Stonehouse was put in during the 1860s. A steam engine service, affectionately known as the Dudbridge Donkey, pulled carriages through the station for many years. The author's mother travelled along the line on a daily basis while attending Stroud High School for Girls around 1915. The later photograph, from 1985, shows all that was left of the station site following road widening.

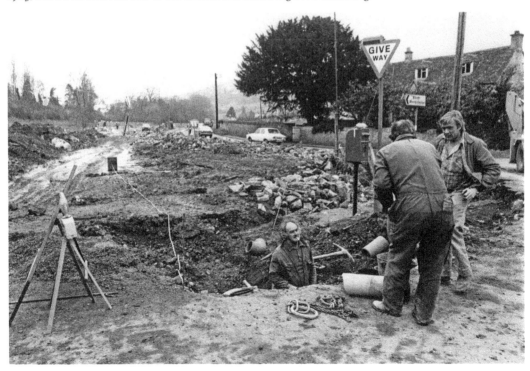

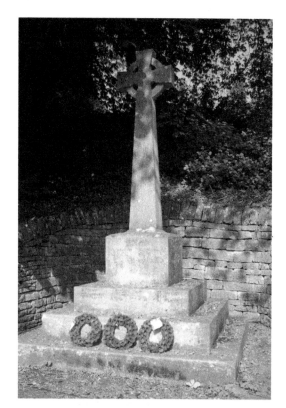

The War Memorial

It is probable that the earlier photograph shows the War Memorial at the time of its unveiling just after the First World War. Interestingly, the name inscribed at the top left of the monument is that of George Arthur Shee, who lived briefly in the parish and who is better known to posterity as 'The Winslow Boy'. In the modern picture, names from the Second World War have been added in on the lower level.

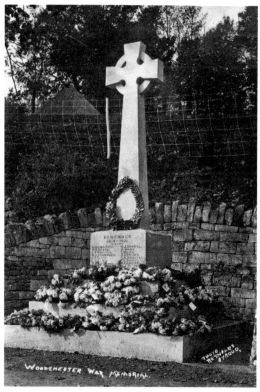

WOODCHESTER WAR MEMORIAL.

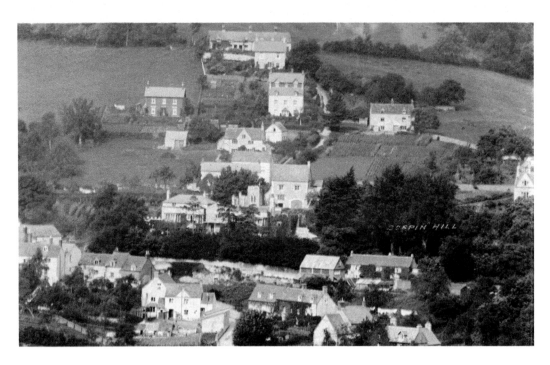

South Woodchester

In the 1910 image Tower House is visible in the centre, with the Ram Inn towards the bottom of the picture. Bospin Lane is at the top. The modern photograph shows rather more of South Woodchester. Both were taken from a vantage point across the valley at Houndscroft.

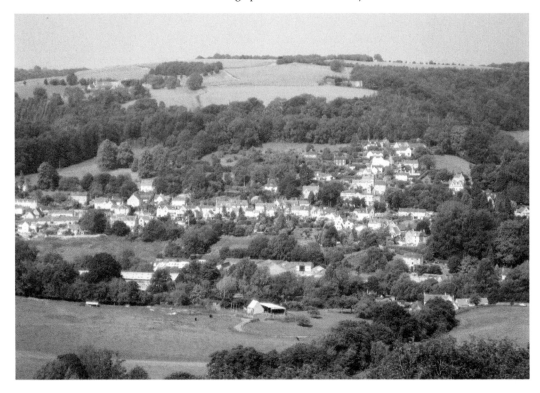

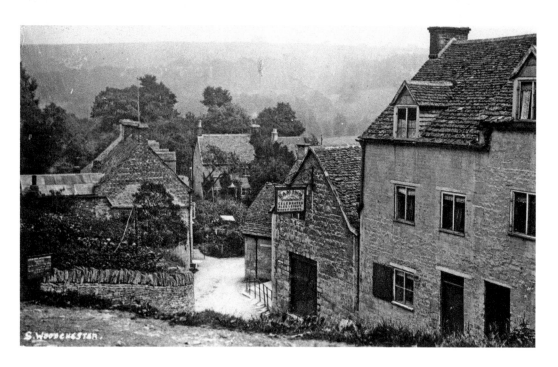

The Ram Inn

When the sepia picture was taken, around 1910, Henry Dowling was landlord of the Ram Inn. The attractively painted sign makes it clear the pub was supplied with 'Stroud Brewery's celebrated ales and stout, wines and spirits'. During the ensuing century the wide goods access door onto the road has been blocked up. That apart, the pub and other buildings nearby remain substantially unaltered.

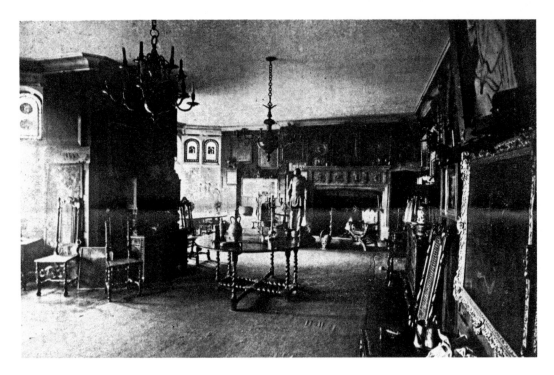

Tower House

In 1903 Tower House was on the market. The sale catalogue has survived in which it is claimed to be a 'XIVth Century Residence with a front resembling Haddon Hall'. The photograph included here shows the interior with its panelling and fine fireplace. The sales information continues: 'the social amenities are excellent, the neighbourhood abounding in County Seats and other Country Residences'. In 1941 Tower House served a very different purpose, housing the Great Britain Film Library. The second picture is of reels of film being despatched from the front door to a waiting vehicle.

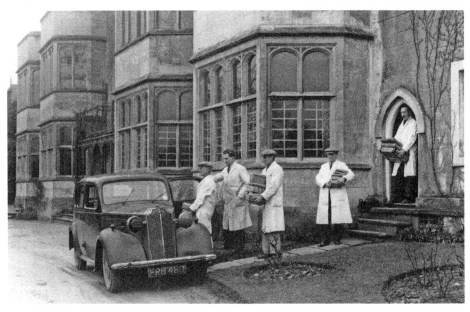

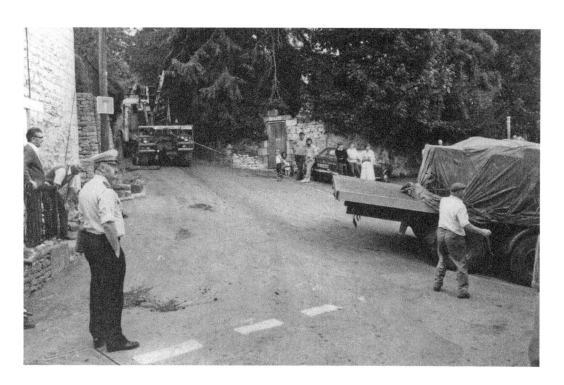

Traffic Problems at Bospin Lane

The Edwardian scene is of the junction of Bospin Lane with the High Street in South Woodchester, just before the First World War. What is now a private house was then evidently a shop – there were more than a dozen in the parish in 1910. The later view is of the same junction, but from the opposite side, and was taken in July 1984 when a lorry became jammed across the corner and lacked the power to reverse out. It had to be winched free. Reportedly, its rescue took a motorway recovery vehicle more than two hours to achieve.

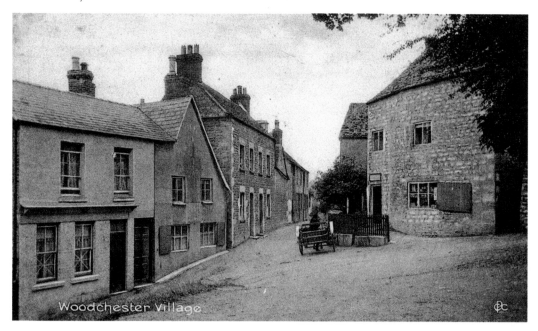

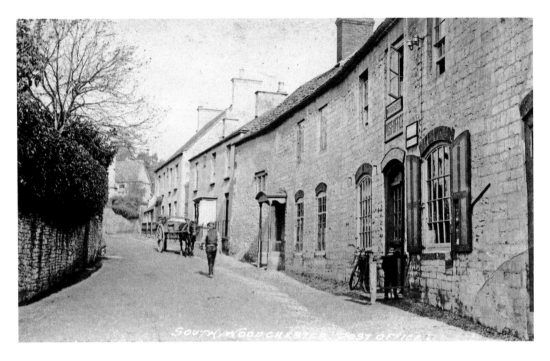

South Woodchester Post Office

In this delightfully sleepy Edwardian view of the High Street taken by Stroud photographer Mark Merrett, a postman's bicycle and a small boy are by the Post Office door, while a pony and trap can be seen a little further away. In the 2010 picture the buildings, including a wooden porch, are much the same, but cars dominate the street. The postmistress in 1910 was a Miss Elsie Gorton.

Frogmarsh

The clarity and focus of 'The Pin Mill' picture marks it out as the work of Nailsworth photographer E. P. Conway. By 1863 the mill was occupied by a firm of pin-makers, Perkins, Critchley & Marmont, which continued in business until 1934. Like most mills in the district, it is now divided up into various smaller industrial units, notably the Bottle Green drinks firm. The right-hand part of the four-gabled building on the left was formerly the Ten Bells Inn.

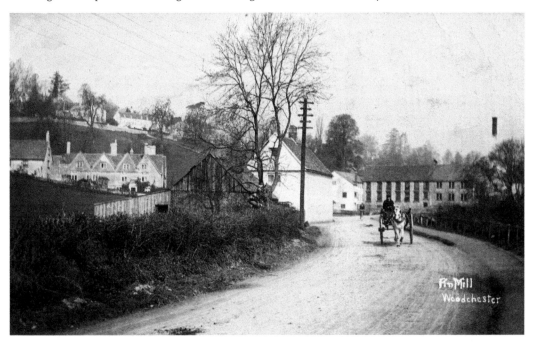

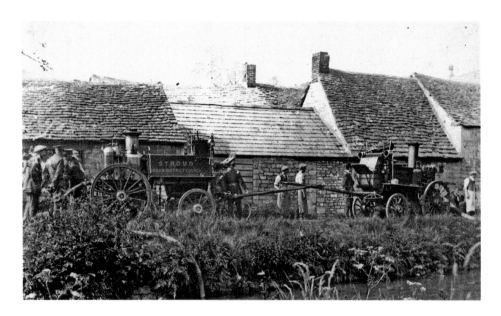

Matthew Grist's Mill

A fire occurred around 1910 at the premises of 'Matthew Grist, washed wool and mill puff manufacturer', as the trade directories described the firm. Both Stroud appliances attended – plus two from Nailsworth and, initially, reinforcements from Gloucester. The early photograph shows water being drawn from the nearby stream into the steam-powered engines. The buildings shown behind them appear not to have survived. At this period the procedure for attending a fire was as follows: wood was laid ready in each machine, lit when the call came in and the boiler was fired up by the draught created by the movement to the location of the fire. The 'steamer' was then ready to pump on arrival. The modern photograph shows surviving buildings now used by a variety of enterprises.

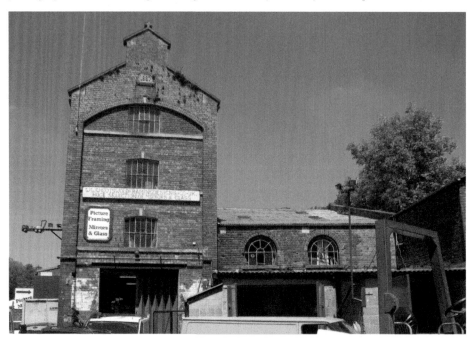

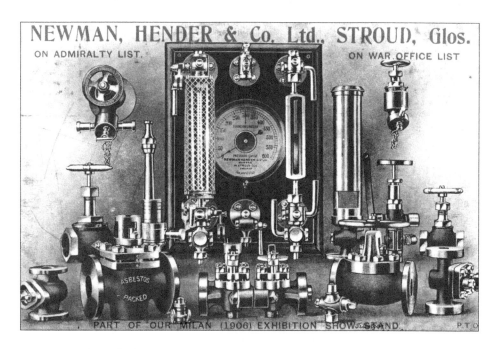

NEWMAN, HENDER & Co. Ltd., STROUD, Glos.

ON ADMIRALTY LIST. ON WAR OFFICE LIST

PART OF OUR MILAN (1906) EXHIBITION SHOW STAND. P.T.O

Newman and Hender's

Newman and Hender's brass founding firm had its roots in the nineteenth century. The decorative 1906 trade card reproduced here shows some of the products it made and also proudly records contract connections both with the Admiralty and the War Office. The firm was involved in munitions work during the First World War. Now taken over by a range of small businesses since the factory closed in the 1980s, the distinctive main building is still very much a feature of this part of the parish.

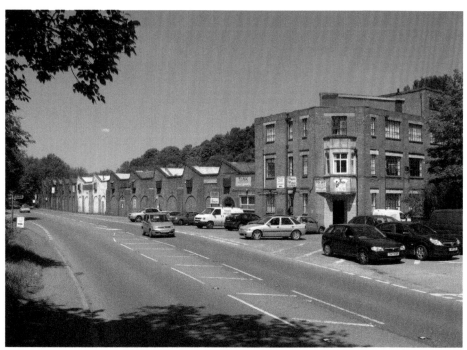

87

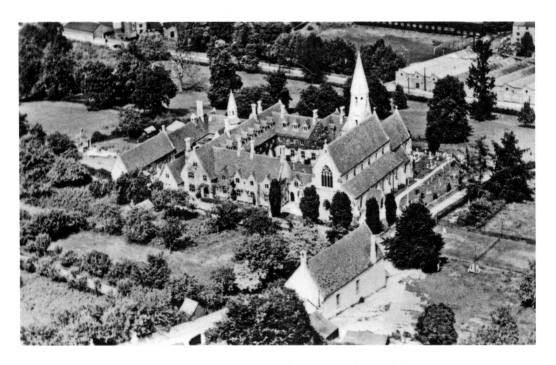

The Dominican Priory

Passionist Fathers were introduced to the Pud Hill area in 1849 when the Roman Catholic church, designed by Charles Hanson, was opened. A year later the Passionists were replaced by Dominican monks. The domestic buildings of the monastery were demolished around 1970. The aerial view above dates from about 1920. The lower image shows the church as it is today. The inset, possibly dating from the 1860s (and recently discovered), is probably one of the earliest surviving views of the monastery.

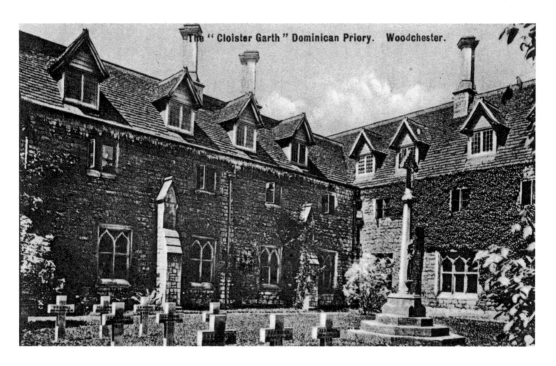

The "Cloister Garth" Dominican Priory. Woodchester.

The Monastery Courtyard

The 'cloister garth' of the Dominican Priory is clearly identifiable in both pictures by its central monument and simple monastic grave crosses. Catholicism was revived in the area by William Leigh, who purchased Spring Park – now known as Woodchester Mansion – in 1846. Apart from the Priory and the Mansion, Leigh was responsible for the foundation of a Franciscan Convent of Poor Clares in the parish. His influence is also evident at Nympsfield.

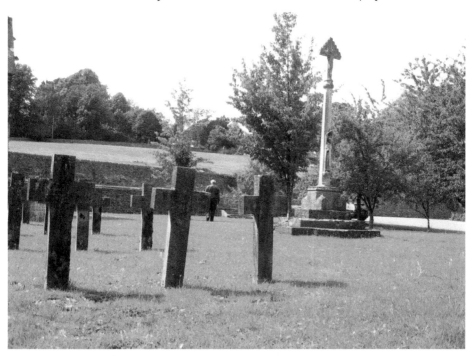

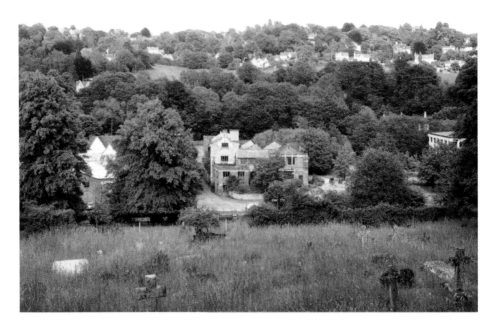

View from the Priory Grounds

Posted in Nailsworth in 1913 and published by a well-known Swindon firm, the postcard shows Newman and Hender's factory on the left before the long building with its distinctive roofline was put up. Giddynap House is visible part-way up the hill – still just detectable through the trees in the modern picture. Note how building development has taken place on the right in the distance.

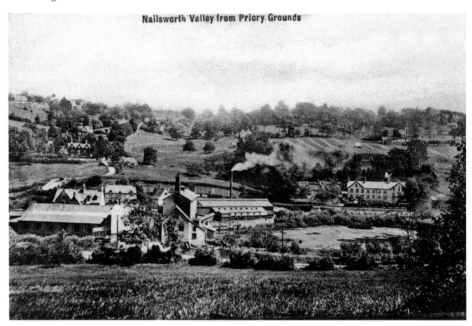

90

A Seasonal View

People a century ago were fascinated by snow. Many winters at this time were hard and extended, the most notable being the great frosts of January 1908 and 1916. The postcard of the Dominican Priory was franked on 23 January 1910. The colour picture dates from February 2010 and is a reminder that hard winters seem to have returned recently.

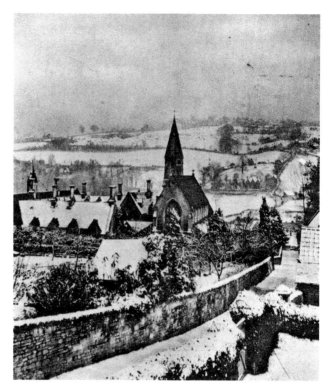

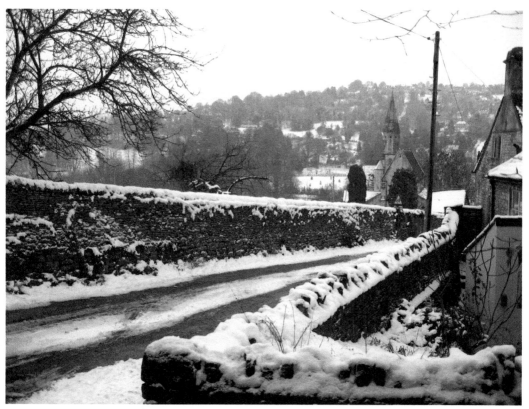

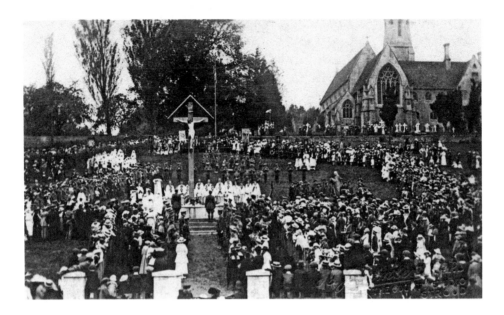

The Wayside Cross

On 4 August 1918 a service to mark the fourth anniversary of the start of the First World War was held at the Wayside Cross – erected some fifteen months earlier. The day was referred to as Remembrance Day. (At this time, of course, the war had not ended and 11 November was not observed as a time for commemoration.) His Eminence Cardinal Bourne preached at The Cross to a crowd of some 4,000 to 5,000 people. He had spent the previous night at the Monastery as the guest of the appropriately named Father Pope. Amberley Brass Band accompanied the hymns, Australian soldiers formed a guard of honour and three volleys were fired by members of the Gloucestershire Voluntary Regiment, which also provided buglers for the Last Post. A film of the event was later shown at the Picture House Cinema in Stroud.

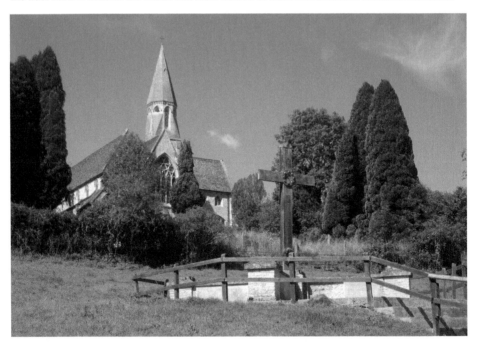

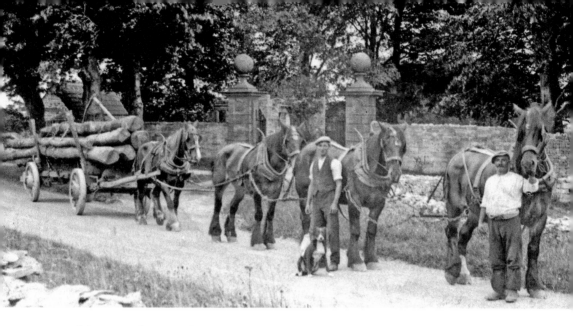

Woodchester Park, Nympsfield Entrance

Over recent years, the ownership of Woodchester Park by the National Trust has once more enabled visitors to explore this glorious valley. A minibus service down the long drive is available on open days for those wishing to visit the Mansion. The fine Edwardian picture shows a team of working timber-haulage horses. The 1915 colour postcard view was not taken from exactly the same spot, but seems an appropriate partner for it. On its reverse is advertised the chance, for 2/6 plus two stamps, to send a framed cameo photo to a loved one out fighting in France.

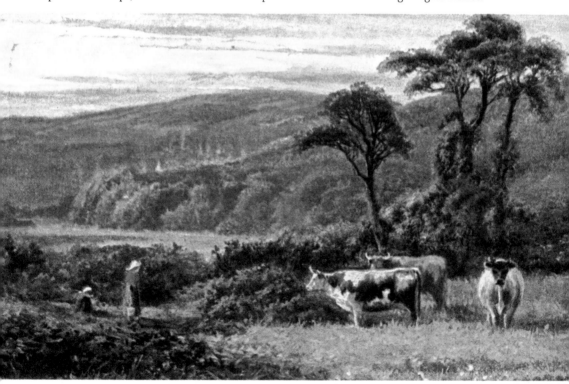

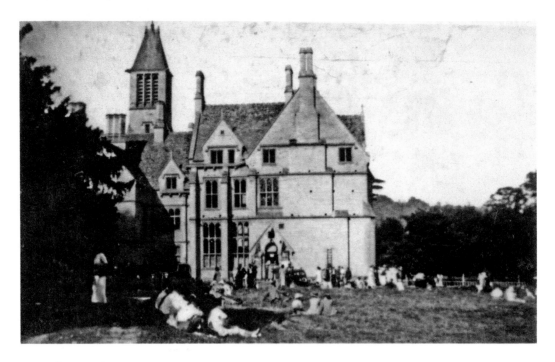

The Mansion

The sepia picture, a family photograph taken in 1937, shows crowds relaxing – as they had done for decades – outside the iconic Mansion building. The colour image is of a much later occasion when a local chamber choir, The Cappella Singers, performed a concert on 30 June 2001 in the only completed main room in the building.

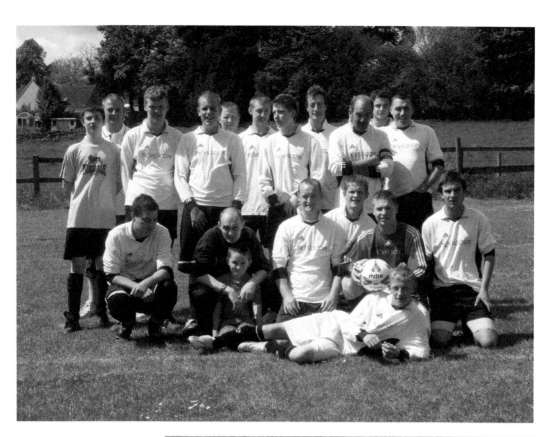

Football

The beautifully mounted picture of the Woodchester and Amberley Association Football Club was kindly loaned to the author by local history enthusiast Paul Aston. Football is still played in Woodchester and the modern image is a recent team photograph.

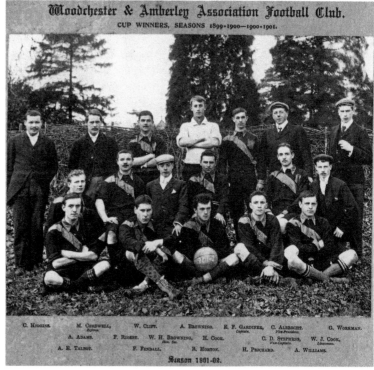

Woodchester & Amberley Association Football Club.
CUP WINNERS, SEASONS 1899-1900—1900-1901.

C. Higgins. M. Cordwell, *Referee.* W. Clift. A. Browning. E. F. Gardiner, *Captain.* C. Albrecht, *Vice-President.* G. Workman.

A. Adams. F. Rigby. W. H. Browning, *Hon. Sec.* H. Cook. C. D. Stephens, *Vice-Captain.* W. J. Cook, *Linesman.*

A. E. Talbot. F. Fendall. R. Horton. H. Prichard. A. Williams.

Season 1901-02.

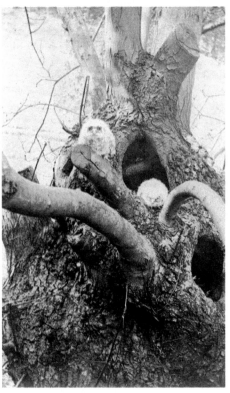

Wild Nature

The house in the modern picture is Pear Tree Cottage in Selsley Road, North Woodchester. The sepia view of owlets was sent from this address on 17 August 1923. On its reverse, a message refers to family health matters and a book which the postcard writer's father has read. Although the birds are not mentioned, we may assume that the photograph was taken in the garden, or nearby. It provides a whimsical, light-hearted conclusion to this book.

Acknowledgements

G. Adams, P. Aston, Revd N. Baker, A. Beale and the Staff of the Nailsworth Archive, Mrs J. Bernard, Mrs P. Buckenham, C. Chamberlain, Miss C. Cook, M. Daynes, D. Drew, Bruce Fenn Photography, B. Greening, P. Harris, R. Harris, Mrs B. King, Mrs M. Lee, G. March, D. Markey, A. Peacey, S. Peart, S. Robinson, B. Saunders and The Nailsworth Dramatic Society, G. Soutar, V. Southcott, T. Walters, A. Weir.

To Miss D. Fowler, Mrs T. Greening, P. Griffin and Mrs A. Makemson I am grateful for proofreading the text and to my wife, Sylvia, for all her help and encouragement.